GOLUB

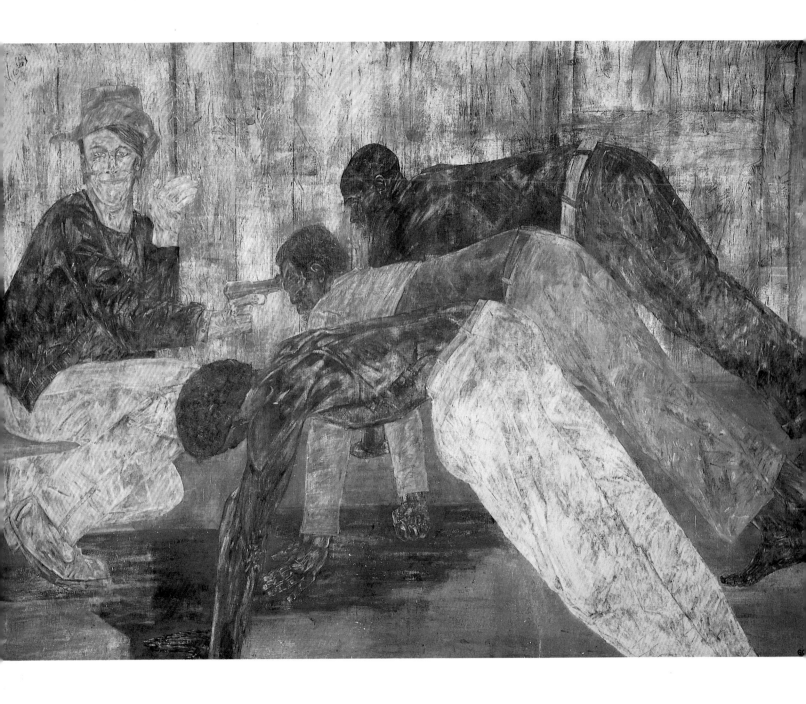

GOLUB

Lynn Gumpert

Ned Rifkin

The New Museum of Contemporary Art, New York

The New Museum of Contemporary Art, New York
September 22-November 25, 1984

La Jolla Museum of Contemporary Art, California
December 14-January 27, 1985

Museum of Contemporary Art, Chicago
February 8-April 7, 1985

The Montreal Museum of Fine Arts, Canada
April 18-June 2, 1985

Corcoran Gallery of Art, Washington, D.C.
July 6-September 8, 1985

Library of Congress Catalog Card Number: 84-60926
Copyright © 1984 The New Museum of Contemporary Art
583 Broadway, New York, New York 10012
ISBN 0-915557-44-4

Frontispiece
Catalog 41. *Mercenaries V*, 1984.
Acrylic on canvas, 120 × 172".
Collection of Doris and Charles
Saatchi, London
Source for painting from a photo-
graph by J. Roth Baughman.

This exhibition is supported in part by grants from the National Endowment for the Arts, Washington, D.C., a federal agency; the New York State Council on the Arts; and by public funds from the New York City Department of Cultural Affairs.

Contents

Lenders to the Exhibition

Wayne Andersen, Boston

The Art Institute of Chicago, Illinois

Eli and Edythe L. Broad, Los Angeles

Milton Brutten and Helen Herrick, Philadelphia

Lori and Alan Crane, Chicago

Leon Golub, New York

Philip S. Golub, Wiesbaden, West Germany

Stephen S. Golub, Swarthmore, Pa.

Ulrich E. Meyer and Harriet C. Horwitz, Chicago

The Montreal Museum of Fine Arts, Canada

Museum of Contemporary Art, Chicago

Paul and Camille Oliver-Hoffmann, Chicago

Doris and Charles Saatchi, London

Fritzie Sahlins, Chicago

Nancy Spero, New York

Gene Summers, Los Angeles

Private Collection

Preface

Leon Golub has been a model for his peers as well as for a younger generation of artists for over forty years because of the uncompromising honesty and consistency of his vision. Golub's work provides us with a study of power in both its personal and political manifestations, rendered with formal grandeur and acumen. His penetrating images of the contemporary world, founded on art historical sources, are situated, now as then, outside the aesthetic mainstream, and they are firmly rooted in the world of ideas as well as experience.

Even in 1981, when this exhibition was being planned by Curators Lynn Gumpert and Ned Rifkin, Golub's work seemed unfashionable and anachronistic. His huge, flat, confrontational, and highly topical paintings had scarcely any audience outside of other artists and a few staunch champions among art critics and curators.

The picture has changed, due to a return of figuration as the mainstream style, along with America's loss of innocence, beginning with the Vietnam war and continuing with recent activities in Central America. Golub's work is now being accorded its just recognition after many years of public neglect. It is our hope that this retrospective exhibition will affirm Leon Golub as one of the most powerful and articulate artists in America today, and that it will give his work, at long last, the attention it so richly deserves.

My thanks to Lynn Gumpert and Ned Rifkin, who organized the exhibition, for providing us with an in-depth look at Golub's work both in the selected paintings and through their catalog essay. We salute the National Endowment for the Arts, the New York State Council on the Arts, and the New York City Department of Cultural Affairs for their support of this exhibition. Above all, our gratitude to Leon Golub whose work and ideas, both compelling and profoundly disturbing, have helped to change our view of the world in which we live.

Marcia Tucker
Director

Acknowledgments

This exhibition and catalog are the results of the collaborative efforts of many talented and dedicated individuals. We are deeply indebted to Marcia Landsman, Publications Coordinator, who along with Lisa Parr, Curatorial Assistant, had the formidable task of organizing both the exhibition tour and catalog. Registrar John Jacobs expertly arranged for the shipping and transportation and Preparator Eric Bemisderfer and crew ably installed the exhibition. We would also like to acknowledge Melissa Harris' diligent efforts in researching and compiling the bibliography; Deborah Weis and Jeanne Breitbart for their sustained assistance in proofreading and typing, and their overall aid; Tim Yohn and Anne Glusker for their perceptive and incisive editing; and Katy Homans, for the handsome design of the catalog. All of this was, once again,

accomplished under the inevitable time pressures. We are also very grateful to Marcia Tucker, whose unwavering support and enthusiasm for this project has indeed made it possible.

We are likewise most appreciative of Susan Caldwell and Elyse Goldberg of the Susan Caldwell Gallery, New York and Rhona Hoffman of the Hoffman Gallery, Chicago. We would like to thank the many individuals who have generously lent works from their private collections to this exhibition and its extensive tour: Wayne Andersen, Eli and Edythe L. Broad, Lori Crane, Helen Herrick and Milton Brutten, Ulrich E. Meyer and Harriet C. Horwitz, Paul and Camille Oliver-Hoffmann, Doris and Charles Saatchi, Fritzie Sahlins, and Gene Summers. We are most grateful to James Speyer and Anne Rorimer for facilitating the loan of the painting from the Art Institute of Chicago. We are also indebted to the following for their efforts in arranging their respective institution's participation in the tour that follows the showing at The New Museum of Contemporary Art: Michael Botwinick and Jane Livingston at the Corcoran Gallery of Art, Washington, D.C.; Pierre Théberge at The Montreal Museum of Fine Arts; Mary Jane Jacob at the Museum of Contemporary Art, Chicago; and Hugh Davies, Lynda Forsha, and Burnett Miller at the La Jolla Museum of Contemporary Art. Coosje van Bruggen also was extremely helpful in offering advice and assistance in contacting European institutions. In addition, we would like to acknowledge Joseph Dreiss, whose unpublished Ph.D. dissertation on Leon Golub for SUNY, Binghamton, provided much important information, especially on his early career. We are also very grateful to Nancy Spero, for her patience and generosity in opening the loft to our many inquiries and lengthy discussions, often in the early morning hours. Indeed, it has been a privilege for us to have worked with Leon, whose self-effacing yet determined attitude has inspired all who contributed to this project.

Lynn Gumpert
Ned Rifkin
Curators

Foreword

In 1954, when reviewing Leon Golub's first New York solo exhibition of paintings, Emily Genauer of the *Herald Tribune* remarked, "Clearly this young man from Chicago is to be the art world's new darling." Thirty years of hindsight enables us to critique the critic who, in this case, made this cynical prediction among some rather unflattering observations about Golub's work. The irony, of course, lies in the fact that after early critical approbation and even a measure of commercial success, Golub was largely ignored by the art world's prevailing powers. Fortunately, a handful of critics, dealers, and curators have been able to give his work exposure at crucial times.

In the past three years, a renewed interest in Golub's work has surfaced, dove-tailing with the recent fascination with figurative and expressionist painting. Yet over the past two decades Golub has been an important presence in the New York art world, due in part to his predilection for voicing his opinions, often in prominent art journals. Moreover, his unwillingness to compromise his vision, despite the vagaries of art world fashions and trends, and his steady commitment to social as well as aesthetic concerns, have always been widely admired by his peers.

Golub himself acknowledges his relative isolation, vis-à-vis the mainstream, which has only served to strengthen a profound commitment to his singular endeavor. As Golub explained to Michael Newman during an interview two years ago:

> . . . when things aren't working for you, you have to question what goes on, how you're operating, what are the limits. And if you're on the fringe, you'll develop a perspective on what it means to be on the fringe. . . . So the notion of viewing power at the periphery has to have some connection with my frustration at being peripheral myself.*

Since a considerable body of scholarship exists on Golub's art, as documented by the Bibliography, this essay was written to provide readers with an overview and introduction to the concerns in Golub's work. Ned Rifkin conceived and wrote the first draft, Lynn Gumpert reshaped and edited this, and both curators contributed to its final form. We have also included a selection of the artist's statements, arranged chronologically, excerpted from interviews and published as well as unpublished writings.

This exhibition, then, celebrates the bold perseverance of one artist's vision. We have focused exclusively on his paintings since they constitute Golub's major undertaking, although he has also made drawings and prints. The monumental scale of most of Golub's paintings of the last twenty years limited the number of works that could be included, so we have chosen those we feel best indicate the development and direction of the artist's ideas, with an emphasis on the recent work.

While Leon Golub did not become "the art world's new darling," as one critic had projected, he is an artist of considerable intelligence and integrity, whose work—primarily concerned with the nature of power—remains remarkably powerful itself.

LG
NR

* Michael Newman. "Interview with Leon Golub," Leon Golub, Mercenaries and Interrogations. London: Institute of Contemporary Arts, 1982, p. 11.

9

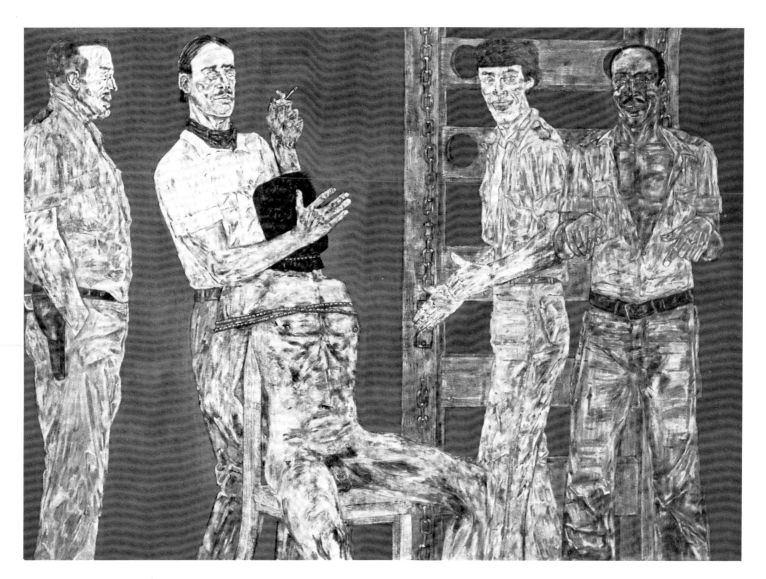

Catalog 34. *Interrogation II*, 1981.
Acrylic on canvas, 120 × 168".
Collection of the Art Institute of
Chicago

On Power and Vulnerability: The Art of Leon Golub

Ned Rifkin and Lynn Gumpert

1 The American College Dictionary *(New York: Random House, 1958),* p. 950.

2 *Max Kozloff, "American Painting during the Cold War," Artforum 11, no. 9 (May 1973): 43–54.*

3 *Unless otherwise indicated, all quotations are from unpublished interviews and conversations with the artist and Ned Rifkin.*

"Potere," a Latin infinitive, is the root of the English word "power" and literally translates as "to be able." Hence the most general definition of power is "the ability to do or act; capability of doing something or effecting something." Yet ability alone does not engender power. It is "the possession of control or command over others," a further definition, which reflects the social and political implications of this word whose synonym is "strength." [1]

Over the span of human history, countless regimes, nations, and empires have risen and fallen as the balance of power has shifted. During the past two decades, the United States, a country whose national identity is tied up with its sense of strength, has seen an ebbing of its power in the international arena. Such events as the war in Vietnam and its domestic repercussions, the Arab oil embargo, the Watergate break-in, the Iranian hostage crisis, and more recently, the Abscam revelations have made Americans both suspicious of those in power and more aware of our vulnerability. This is reflected on a popular level in the new genre of television programs exemplified by "Dallas" and "Dynasty" which are presently among the most highly rated in viewer polls. These soap operas, focusing on influential individuals' lust for power and the "dirty tricks" used in order to attain it, manifest a national fascination with the mechanisms of power and vulnerability.

Since World War II, the fine arts, on the other hand, have remained rather aloof from questions of fluctuating world power. More than ten years ago, Max Kozloff advanced the theory that multinational corporations set the tone for the cool, detached world view that had superseded the heroic timbre of Abstract Expressionism. [2] Leon Golub, a figurative painter who has continuously made unambiguous personal and political statements in his work during this same time, rejected this distanced approach. He has been working with the notion of power and vulnerability, for him the axis of human existence, since he began making art in the mid-1940s. He has pursued this theme with a remarkable consistency, determined to forge a personal statement that activates both social and aesthetic concerns. His variations on this theme have evolved from a highly subjective approach centered on his individual potency as an artist to a more outward-looking stance that engages the external world.

Golub has deliberately aspired to create an accessible art, one that is "immediate and absolutely up front" in the way it deals with its principal subject – power. "I am closer than most artists to actually replicating in my work how power is really used," he has said. [3] For him, an artist must invoke another definition of power, the one used in optics to mean "the magnifying capacity." One of Golub's primary goals has been to have his work reflect and utilize the mechanisms of power in a microcosmic way in order to throw light upon power in the

4 Michael Newman, "Interview with Leon Golub," Leon Golub, p. 11.

5 At some point during this period, Golub became friendly with a graduate student, Peter Selz, who was then researching the relatively unexplored area of German Expressionism. He would later play an important role in Golub's early career.

6 Golub wanted to write his master's thesis on Dada, like German Expressionism, an early twentieth-century movement in Germany that had only been sketchily researched. In a certain sense the artist's interest in Dada presages the political aesthetic in his own work by thirty years.

7 The themes of violence in his student work surfaced in his early paintings of human figures inspired by newspaper photographs of Holocaust victims. He made a lithograph called Charnel House (1946), which borrowed its title directly from Picasso. Much of his work at this time reflected proto-expressionist sources — for example, Francisco Goya's Disasters of War (c. 1810) aquatints, James Ensor's paintings of masks and skulls, and Edvard Munch's haunted prints and paintings.

greater realm outside an artist's studio. His continued probe of the individual's power as it exists in the world at large has led Golub to examine extreme conditions. He explained during an interview recently:

> If you want to comprehend a phenomenon, you have to go to the edges or perimeters where it slips into something else, or where its contradictions or isolation become evident. To figure out aspects of American power, or power in general, you have to look at power at the peripheries. [4]

Leon Golub is still often considered a "Chicago artist," although he has resided in New York for more than twenty years. His connection with Chicago, however, is an important one. He was born there in 1922 to a middle-class Jewish family. His parents encouraged his early interest in art by sending him to children's classes at the School of the Art Institute. Years later, Golub attended Wright Junior College in Chicago, where he was first exposed to the history of art. His success there won him a scholarship to continue his art historical studies at the more prestigious University of Chicago, where he received an undergraduate degree in 1942. [5] His graduate studies in art history were interrupted when he enlisted in the military, serving in England, Belgium, and Germany as a cartographer of aerial reconnaissance maps. After the war, he resumed his studies at the University of Chicago, [6] but then enrolled instead at the School of the Art Institute, where he received a BFA in 1949 and an MFA in 1950.

Although Golub's military service did not take him into direct combat, his experience of the war profoundly affected his orientation as an artist. The Holocaust—which had only been the subject of rumors in the United States until the end of the war—and the atomic bombings of Hiroshima and Nagasaki provided Golub with the theme of violence around which much of his student work revolved. [7] During this time, he frequented Chicago's Field Museum of Natural History, where he, and some of his fellow art students, discovered a wealth of primitive art. [8] The visual impact and ritualistic connotations of sculptural artifacts from African, Oceanic, and Northwest Coastal Indian cultures were to provide important sources of inspiration for a number of years.

The atmosphere of the School of the Art Institute was particularly charged at that time, due in part to the presence of more mature ex-GIs like Golub. Indeed, when faced with a decision that would make students ineligible to enter the Art Institute's annual juried exhibition they rebelled, with Golub emerging as one of the leaders. Although the protest ultimately failed, it did generate an alternative forum, "Exhibition Momentum." Beginning in

8 *An instructor of art history at the Art Institute, Kathleen Blacksheer, was instrumental in directing Golub and some of his fellow students to the Field Museum. Most prominent in this group were Cosmo Campoli, George Cohen, Seymour Rosofsky, Franz Schulze, Dominic DiMeo, Ray Fink, John Waddell, Don Baum, June Leaf, and Ted Halkin. Schulze, now one of the best-known art critics from Chicago, gave this group the name "Monster Roster" in 1959. Nancy Spero, had sent Golub a copy of* Art Aujourd'hui, *which reproduced art of the insane or "l'art autre," another early influence, when she returned from a year of studying in Paris in 1949.*

9 *Among the impressive list of jurors were Jackson Pollock, Clement Greenberg, Ad Reinhardt, Robert Motherwell, Sam Hunter, Philip Guston, Franz Kline, Alfred Barr, Betty Parsons, Max Weber, Sidney Janis, Adolph Gottlieb, James Johnson Sweeney, and Jack Tworkov.*

10 *From 1947 until 1951, Golub underwent Freudian psychoanalysis.*

11 *The word "author," he or she who originates, is the root of the word "authority." At this time, Golub was reading James Frazer's* The Golden Bough.

1948, Golub and his colleagues imported a number of important New York artists, dealers, and critics as jurors for the large and unrestricted group exhibitions.[9]

Once out of school, Golub married a fellow student, artist Nancy Spero. He soon began teaching in order to help support their first child, born in 1953. His penchant for working in groups of thematically related drawings or paintings continued, a method that he has retained to the present. In 1951, he initiated a series depicting priests, shamans, dervishes, seers, and kings. In some respects, this theme is tied to fundamental questions about the artist's own identity.[10] These male authority figures served as a model for Golub, who believed that, through the act of painting, the artist could exorcize evil spirits from the social structure. The priest or shaman as a controlling figure relates to the notion of creativity and imagination as a source of individual power.[11] Judging from a statement Golub made in 1950, he saw a parallel between the shaman in primitive cultures and the role of the artist in contemporary society:

> *Once art was part of the utilitarian apparatus for sacred and secular behavior. It partook of myth and magic, ritual and revelation, pageantry and education. Society and culture heroes were glorified. The arts still represent this but in a more fragmentary form as vehicles for adaptivity in highly personal idioms.*[12]

A few years later, Golub's aspiration that painting be a magical act corresponded to what he then described as the "dervish principle – that the prime elemental resources within the psyche have intense pictorial equivalents."[13] Furthermore, his figures' frontality and symmetry imply, as Lawrence Alloway has pointed out, a "mirror-image of the artist before the canvas," thus reinforcing the notion of self-portraiture.[14]

Often, these male frontal authority figures are engaged in a "gesture of evocation."[15] In *The Princeling* (1952), which bears the stylistic influence of Jean Dubuffet,[16] both hands are spread horizontally in a ritualized manner. As with most of Golub's works throughout his career, the feet are cropped, in what he has called "a deliberate distancing device" that modifies the artist's intense subjective vision.

A simultaneous and complementary theme surfaced from 1952 to 1955. While retaining the frontal figural format of the powerful men, Golub's "Victim" series also manifests the vulnerability that was so profoundly in evidence during the war years. *Thwarted* (1952–53; fig. 1), one of the first in the series, was inspired by the famous Belvedere Torso in the Vatican Collection, a remnant of a full seated figure that has for centuries inspired artists. Golub has stated:

12 *Golub, "A Law Unto Him-
self," Exhibition Momen-
tum – A Forum, n.p.*

13 *Golub, "A Critique of Ab-
stract Expressionism," Col-
lege Art Journal, p. 146.
This principle is cited as a
shortcoming of Abstract Ex-
pressionism, although he
also saw it as a desirable
goal for all artists, but one
which may well not be
attainable.*

14 *Lawrence Alloway, "Leon
Golub: The Development of
His Art," Leon Golub, n.p.*

15 *Joseph Gerard Dreiss,* The
Art of Leon Golub:
1946–1978, *unpublished
doctoral dissertation, State
University of New York at
Binghamton, 1980, p.
56, footnote 9.*

16 *Golub cites Peter Selz as the
person first responsible for
bringing the work of
Dubuffet to his attention
in 1950.*

17 *Irving Sandler, tape re-
corded interview with Leon
Golub, unpublished type-
script, October 28, 1968,
p. 50.*

18 *An earlier work by Golub
that obviously bears the in-
fluence of Greek art is a
drawing entitled* Hellen-
istic Memories *(1946),*

fig. 1. *Thwarted,* 1952–53. Lac-
quer and oil on canvas, 47 × 31".
Courtesy of the artist

*It seems to me that some of the most beautiful things that exist are just pieces of things. When you
come across a Greek fragment, it's very beautiful because this thing still has traces of its original
organic perfection. It's a wonderful kind of feeling in the piece itself. I don't think I'd like it as much
had I seen it in its original state. Let's say it's been hurt.* [17]

Golub grafted this elegant image onto a more primitive one, an African mask, which
surmounts the broadly expanded chest area. One of the earliest examples of Golub using a
Greek source, this work reveals the artist's fondness for sculptural fragments as subject. [18] In
later paintings in this series, Golub would make overt references to his memories of the
Holocaust – e.g., *Burnt Man* (1954), the first of several paintings with this title (some executed
as late as 1961) – and to flayed skins or carcasses – discernible in *Damaged Man* (1955; Cat. 4).

Catalog 4. *Damaged Man*, 1955.
Lacquer on canvas, 48 × 36″. Col-
lection of Gene Summers, Los
Angeles

19 *Dreiss, pp. 76–80. Paul Schilder's book,* The Image and Appearance of the Human Body, *was published at this time, coinciding with Golub's Freudian psychoanalysis. Golub found it particularly significant to his theories of extreme subjective distortion of the human form. It proposed that the external, physical image of our corporeal selves was merely part of our entire self-image. A student of Freud, Schilder submitted that the internal, psychological view of oneself involved a dynamic, changing, and developing structuralization. Golub, in his desire to have his work anchored in the human condition, undertook a total subjectification of this theme, using floor paints and immediacy of process to create rather monstrous distortions of frontal figures.*

20 *Golub, "A Law Unto Himself," n.p.*

21 *Ibid.*

22 *Golub, "A Critique," p. 146.*

23 *Golub and Spero have three sons: Stephen born in Chicago in 1953, Philip born in Chicago in 1954, and Paul born in Paris in 1961.*

Concurrent with the "Priest" series, Golub began "In-Self," the title indicating his then-central concern, introspection.[19] These emphatically visceral paintings of frontal figures also reflect Golub's commitment to a recognizable subject matter that conveys both ethical and aesthetic concerns. By making these paintings intentionally "ugly and chaotic," Golub intended to pose "a threat to the ordering of society and man's conventional concept of himself."[20] Working from the outside in, Golub evolved an "inverted, fragmented concept of reality that rarely coincided with that of others."[21] Turning inward, Golub felt, was the only chance for the creative artist to reclaim his or her potency and to avoid the nightmarish realities of concentration camps and atomic bombs.

With his commitment to figurative imagery, Golub knowingly relegated himself to a position outside the art world mainstream, then dominated by the New York-based Abstract Expressionism movement. His academic studies encouraged him to see his work in the context of an art historical continuum. In addition, his training as a scholar enabled him to articulate his opinions of his own work and that of others. His view of the limitations of Abstract Expressionism was made public in a "Critique," published in 1955, in which he wrote, "For all Abstract Expressionism's practitioners' strenuous efforts, it is deficient in regard to any intense, ideational involvement of the artist."[22] This essay was the first of a comprehensive series of published articles which are notable for Golub's willingness to express his unpopular points of view.

The birth of Golub's and Spero's son in 1953 inspired a "Birth" series, which continued until 1957.[23] Herein Golub's influences shifted from primarily expressionist sources to the more classical.[24] However, more significant perhaps is the degree of optimism that appears in Golub's work at this time, manifested in part via a changing depiction of the figure in a more open pictorial field.

In the "Sphinx" series of the same period, the forms become increasingly clearly defined. Perhaps the most compelling work from this time is *Siamese Sphinx I* (1954; Cat. 3). While there are several historical sources for this series (e.g., Egyptian and Greek art), it was originally inspired by the family dog, which Golub observed assuming sphinxlike positions. However, this initial inspiration did not restrain the artist from realizing an image which is, as Joseph Dreiss has observed, "the embodiment of conflict and stress."[25] By this time, Golub had expanded his pre-Classical sources to include Assyrian and Hittite art, the latter of which Golub described as "a very debased version . . . of classical art."[26] He was fascinated by the hybrid since "the Sphinx really was at a terrible animal level, man really vulnerable as an animal."[27]

At this time, Golub first received considerable critical attention and achieved some

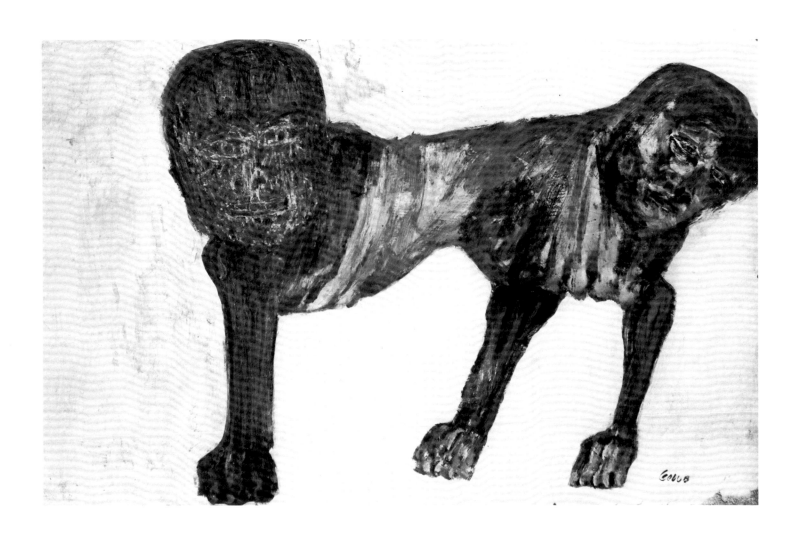

Catalog 3. *Siamese Sphinx I*, 1954.
Lacquer on masonite, 30 × 41″.
Collection of Fritzie Sahlins, Chicago

Catalog 5. *Birth III*, 1956. Lacquer on canvas, 47 × 33″. Collection of Philip S. Golub, Wiesbaden, West Germany

24 *Dreiss, pp. 32–33.*

25 *See Dreiss, p. 115, for in-depth discussion of rela-tionship of the story of Oedipus and the Sphinx.*

26 *Sandler, p. 115.*

27 *Ibid.*

28 *Golub's first solo show in New York was of prints in 1952 at George Wittenborn and Company. The artist's success in 1954, in which five works were sold to Martha Jackson fueled oth-ers. Allan Frumkin, then a dealer in Chicago, began to represent Golub as did the Feigl Gallery in New York.*

29 *Despite his successes, Golub encountered problems with the head of the art depart-ment where he was teach-ing. After Golub criticized this man for reworking a student's painting, and de-fending his own beliefs in modern art, he was fired. A collector friend, Herbert Greenwald, hearing that Golub had lost his job, offered to give him $5,000 to use for painting. He first turned the offer down, feel-ing that he could manage on his own, but six months later, accepted.*

30 *Dreiss, p. 137.*

31 *Sandler, p. 115.*

commercial success in New York. Selected for the prestigious "Young American Painters" exhibition at the Guggenheim Museum in 1954, he also had his first solo show of paintings at New York's Artists Gallery.[28] But this early acclaim was relatively short lived, and Golub soon removed himself even farther from the New York art world.

In 1956, after first declining a patron's offer to finance a year of painting, Golub reconsidered and used the money to live in Italy with his family, spending the summer months on the island of Ischia near Naples.[29] During this time, Golub moved away from the writhing distortions and visceral textures of his earlier work. He began to paint such works as *Ischian Sphinx* (1956) and *Birth III* (1956; Cat. 5) with darker scraped figures contrasting with lighter grounds. He also began to depict space in a more traditional manner, in part owing to a changing attitude toward color – a light blue sky meets a light brown ground in a subtle horizon line, suggesting landscape for the first time in the artist's career. Both paintings' figures reveal an architectural influence. Golub has said that in *Birth III*, he incorporated the image of the dome of a church on Ischia into the anatomy of the woman delivering the child.[30]

Golub discovered two new sources while in Italy. Moving to Florence for the remainder of the year, he was drawn to the "ferociously humane" Etruscan sculptures housed in the Archaeological Museum there. In addition, he revelled in the "barbaric, gross Roman art" that he discovered on his periodic trips to the Italian capital and in the Naples Museum.[31]

Golub's shift in sensibility coincided with his reading the Greek tragedies. He also returned to the male figure after completing the "Birth" series, beginning with a group of paintings based on more athletically active figures.[32] *Orestes* (1956; Cat. 6) was modeled on the sculptural fragments seen in the museums of Florence and Naples. Here, the face of the damaged statue is portrayed as angst ridden, as if due both to the physical mutilation and the prospect of perpetual immobility. In Golub's interpretation of this mythological theme, Orestes – Electra's accomplice in the murder of their mother, Clytemnestra – is imprisoned in the muscular remnant of a classical body, the eyes' torment and guilt directed outward, implicating the viewer as voyeur and witness.[33]

Complementing the physically active stance of *Orestes* is the series of "Philosophers" begun upon Golub's return to the United States, when he began teaching at Indiana University. In *Philosopher III* (1958), a massive seated figure suggests the weighty burdens of intellectual passivity, as opposed to the physical mobility evident in the more active athletes. Whereas the

Catalog 6. *Orestes*, 1956. Lacquer on canvas, 82 × 42″. Collection of Lori and Alan Crane, Chicago

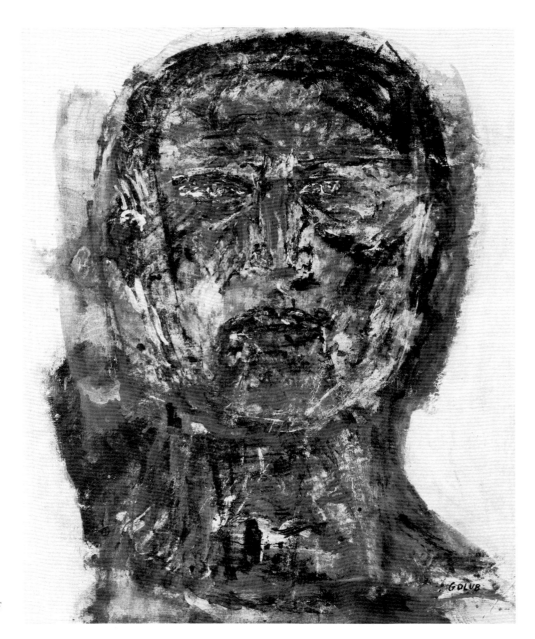

Catalog 12. *Head I*, 1963. Acrylic
on canvas, 46 × 39″. Collection of
Wayne Andersen, Boston

fig. 2. *Colossal Heads I*, 1959. Lacquer on canvas, 81 × 131″. Collection of Ulrich E. Meyer and Harriet C. Horwitz, Chicago

32 Dreiss, pp. 146–47, cites *Golub's appetite for reading as being particularly important at this time. In addition to Freud, Frazer, Schilder, and Roheim, Golub read fiction, especially Kafka, Proust, and Céline. However, he was also interested in Erich Auerbach's* Mimesis *and* Jane Harrison's Themis: A Study of the Social Origins of Greek Religion *and* Prolegomena to the Study of Greek Religion.

33 Orestes *was included in Golub's first solo show in Europe at London's Institute of Contemporary Arts in 1957, then under the direction of Lawrence Alloway, later a supporter of Golub's art in the United States, and author of the Chicago Museum of Contemporary Art's retrospective catalog on Golub in 1974.*

34 *Sandler, p. 68.*

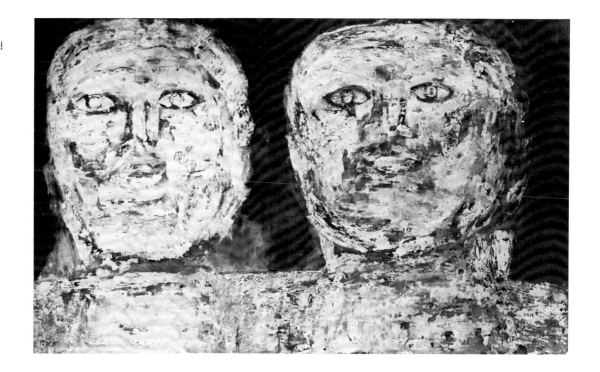

latter group embodied the noble principle of physical fortitude, the philosopher represented "man in control of his environment through rationality."[34] Golub continued to work for some time from the sources he had found in Italy. Roman art in particular influenced and informed a series of colossal heads in 1958. The exploration of the rational, begun with the "Philosophers," was accompanied by a dramatic change in scale—from the easel-sized works of the "Birth" series to the large, vertical format of the athletes and philosophers and then to a series of gigantic heads with dimensions of seven-by-eleven feet (fig. 2; Cat. 12).

The larger scale, made physically possible by a bigger studio at the university, also reflected Golub's desire to mimic the megalomanical aspects of late Roman art—in particular, the heads of the emperor Constantine. Golub also acknowledged his awareness of parallels between ancient Roman and contemporary American imperial power. Describing Roman art as:

The grossest, it's the most bombastic. . . . In the writing of fourth century Rome, in this urban civilization, possibilities have closed down . . . that was just the way the world looked in terms of the West today. . . .[35]

Since 1953, when he discovered that an enamel floor paint he had used in earlier work was deteriorating, Golub's technique has been to promote or accelerate the decaying process, using solvents to break down and dissolve the paint substance. He then scrapes it away with various sculptural tools, leaving an uneven, richly mottled texture. This technique became so important that, as Alloway has noted, the "texture is not a decorative display but a mode of iconography. Its content is the pathos of time's passage and the dissolution of human identity."[36] This tendency to imitate a subtractive sculptural mode, not unlike carving, remains an important element in Golub's work. Yet, after making a few sculptures, he returned to painting. He noted:

The real reason I don't do sculpture is I don't think {my ideas} would work in sculpture. Basically, everything in these paintings — classicism and primitivism and whatever I try to put into it — works in relationship to metaphor, that is to say it works as an idea. If I actually made sculptures of these things it wouldn't be as interesting as the idea of paintings dealing with sculpture dealing with man, dealing with existentialism. It's a complicated series of ideas, none of which are that actual; they're mental things. So that the idea of painting in relationship to sculpture is a better idea for me than to make sculpture itself.[37]

In fact, Golub frequently worked from photographs of three-dimensional sculptures. Always an avid reader and researcher, he had already begun to amass a collection of photographic sources. *Reclining Youth* (1959; Cat. 8) reflects the influence of Hellenistic sculpture "generally by reproductions,"[38] in this case the famous *Dying Gaul* of Pergamon (fig. 3). This shift from the static, hieratic forms of the late Roman Empire back to the more dynamic Hellenistic sculptures of the third century B.C. indicate Golub's growing concern for placing the male figure in motion.

In the spring of 1959, Golub decided to resign his teaching position in Indiana in order to move to Paris. Before he left, an old friend and supporter, Peter Selz, a curator at the Museum of Modern Art, selected five of Golub's paintings for an exhibition entitled "New Images of Man." In the catalog, Golub summarized his work in four brief statements about his use of figures:

35 *Ibid., pp. 122–23.*

36 *Alloway, n.p.*

37 *Sandler, p. 121.*

38 *Dreiss, p. 162, footnote 34.*

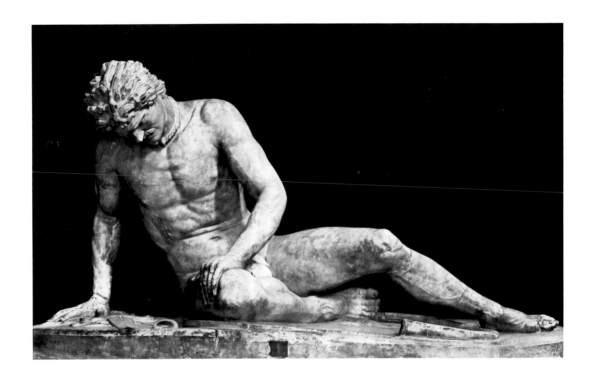

fig. 3. *Dying Gaul* of Pergamon. Musei Capitolini, Rome

1) . . . the stress of their vulnerability versus their capacities for endurance. . . . 2) the enlarged carnal beauty of the fragment . . . contrasted to its pathos and monumentality. . . . 3) attempt to reinstate a contemporary catharsis relating to an existential knowledge of the human condition. . . . 4) figures implacable in their appearance and resistance, stance or state because they know an absolute state of mind {on the edge of nothingness} just as they know a nearly absolute state of massiveness.[39]

Golub and his family lived in Paris for five years on the revenues generated by the sales of his paintings.[40] During this time, his depiction of violence continued to evolve from an inner, psychic turmoil – as witnessed in the expressionistic distortions of the human contour and the heavily textured surface qualities of the earlier works – to a more external depiction of physical violence, objectifying man's struggle against his fellow man. In addition, in 1962 he changed from lacquer to acrylic paint, and this required experimentation in order to discover the new medium's properties.[41]

39 *Leon Golub, "Artist's Statement," in Peter Selz' New Images of Man, p. 76.*

40 *Golub was again offered support by his patron and friend Herbert Greenwald. However, before Golub could move to Paris, Greenwald was killed in an airplane crash. While Allan Frumkin, his Chicago dealer, offered to put up $6,000 per year, he was able to sell* Reclining Youth *(1959), a large painting which Selz included in the "New Images of Man" exhibition at the Museum of Modern Art in New York, later that year.*

41 *Sandler, p. 70. After finally attaining mastery of the lacquer medium, Golub received a letter from Devolac, manufacturers of the lacquer paint he had been using since 1956, explaining that it would no longer be produced.*

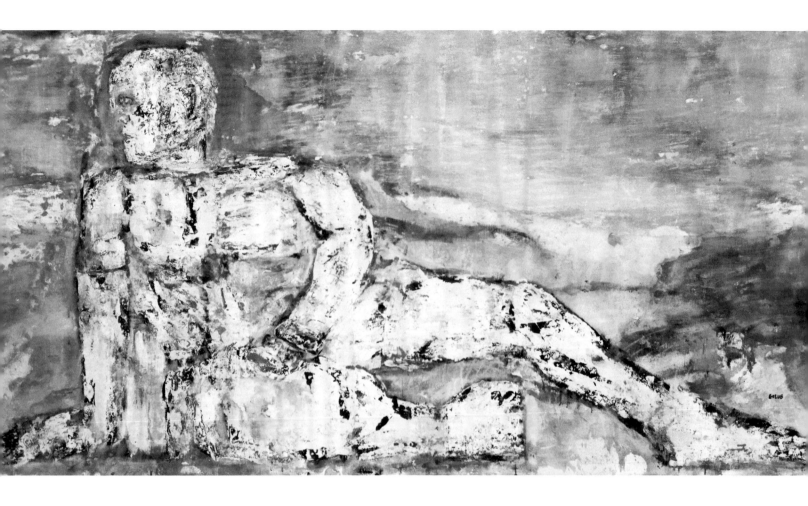

Catalog 8. *Reclining Youth*, 1959.
Lacquer on canvas,
78¾ × 163½". Collection of the
Museum of Contemporary Art,
Chicago; Gift of Susan and Lewis
Manilow

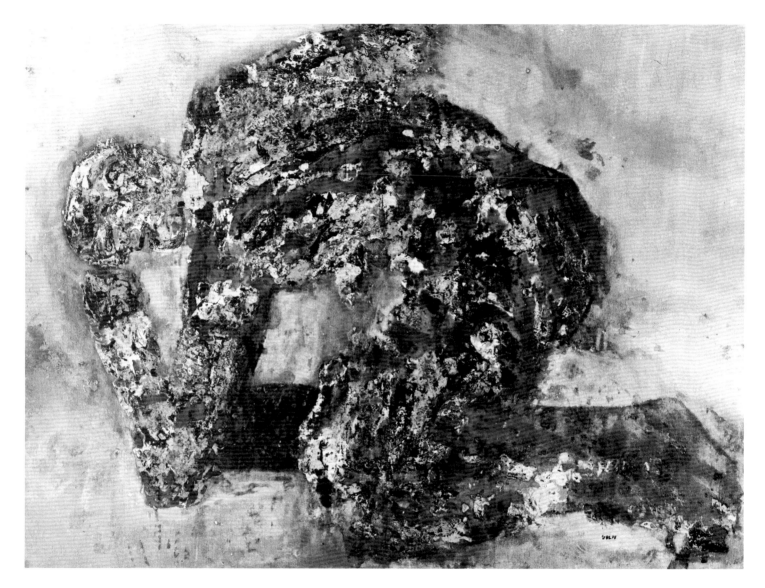

Catalog 10. *Burnt Man IV*, 1961.
Acrylic on canvas, 45 × 61". Pri-
vate Collection

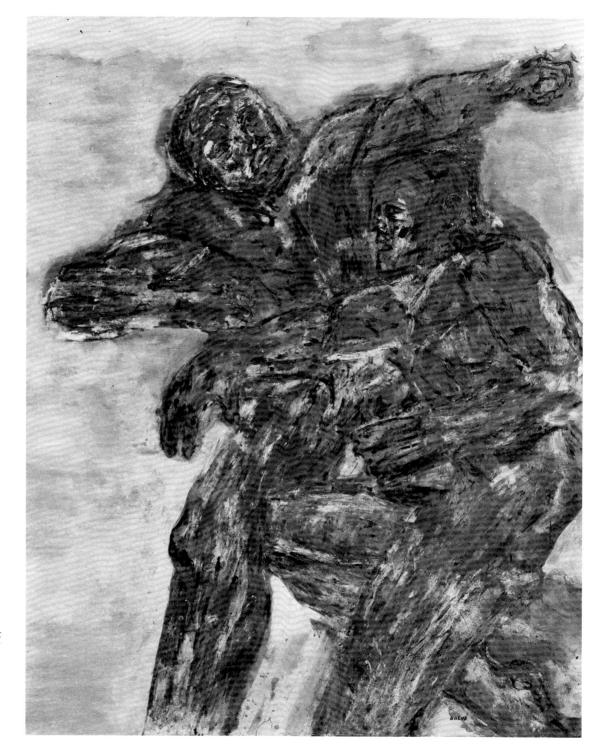

Catalog 11. *Combat I*, 1962. Acrylic
on canvas, 92 × 81″. Collection of
Gene Summers, Los Angeles

Golub at first continued his focus on large male figures, charging the paintings' surfaces with what he termed "the pathos of their erosion,"[42] a quality also evident in the sculpture of Alberto Giacometti, then living as well in Paris. Returning to Hellenistic sculpture (most notably the Great Altar of Zeus at Pergamon) as a source, Golub gave the heroic forms greater mobility. *Horseman II* (1960), based on the genre of equestrian portraits of military leaders, prefigures the more overtly political subjects that would first appear in the mid-1960s.[43] Yet while the massiveness of the depicted figures increased, their vulnerability also grew. The "Burnt Man" series (1960–61; Cat. 10) both harks back to the earlier "Victim" series and points to Golub's mature handling of the Hellenistic sources.

Golub eventually dispensed with the isolated male figure that had long been his primary subject, in favor of double figure compositions. In *Combat I* (1962; Cat. 11), a painting nearly eight feet high, the artist presents two male figures fighting with their hands, the pugilistic theme undoubtedly inspired by the famous Hellenistic bronze *Seated Boxer* (c. 50 B.C.) by Apollonius. Golub's shift from moving single figures of a rider on horseback to the physical clash of two men reflected an increasing desire to comment on social struggles for power. His earlier adaptation of Roman art had to do with the issues of the psychology of the urban, and of "modern" man suffering from social stress. As Golub wrote in a letter to the critic Robert Pincus-Witten at this time, he believed that his work functioned on three levels: "the recall to classic art . . . the breaking-up . . . of these classic schema [and] the reactivation with a contemporary violence."[44]

When Golub returned to the States in October 1964, he moved not to Chicago, but to New York. The newly established center of the international art world was undergoing some radical upheavals at this time. Pop art had made its initial entrée with overwhelming success, and Minimal art was beginning to gather momentum. Action painting had been superseded, on the one hand by the cool abstractions of such artists as Frank Stella and Kenneth Noland and, on the other, by the campy figurations of Andy Warhol and Roy Lichtenstein. Robert Rauschenberg had just returned from the Venice Biennale with his newly won international acclaim, and Jasper Johns, Jim Dine, and Claes Oldenburg were all in high gear. It was also the moment when Lyndon Johnson was about to soundly defeat Barry Goldwater in the presidential election and when the escalation of U.S. involvement in Vietnam was becoming a social as well as political issue.

Not long after he settled in New York, Golub became involved with an organization called Artists and Writers Protest, a politically active group which spoke out against the war in Vietnam. Golub became increasingly politically active helping to organize anti-war exhibitions

42 *Leon Golub, unpublished statement, 1958.*

43 *This image of the "man on horseback," is an icon of the military man with sufficient power to challenge the reigning administration.*

44 *Robert Pincus-Witten, "Golub on Three Levels," iris.time, n.p.*

45 *Dreiss, pp. 193–94, lists influences for the paintings, the subjects of which are drawn primarily from the frieze on the Great Altar of Zeus at Pergamon, depicting the Olympian gods in pitch battle with the earthbound giants. In addition, Golub also acknowledges his awareness of Nicholas Poussin's classical Baroque history paintings. (See also Sandler, p. 146.)*

46 *Sandler, p. 138. Earlier in his conversation with Sandler (p. 113), Golub mentioned that he left Chicago because he was, at that time, "success-obsessed."*

47 *Golub notes that when he saw Orozco's mural at Pomona College it "appeared to be 100 feet high, though I am certain it wasn't. It had a telescoping magnitude." He first saw Guernica in 1939 when it was brought to Chicago by the Arts Club and placed on public view. Later, in 1968, Golub was involved with an attempt to contact Picasso in hopes that he would remove the painting from the United States in protest over the American involvement in the war in Vietnam.*

48 *Leon Golub, unpublished manuscript, 1958.*

and participating in panels on art and politics. To what degree this and other related activities influenced Golub's decisions to change his art is difficult to assess. The most significant change that occurred at this time is visible in terms of scale. *Combat I* was a large painting (92 × 81"), but Golub decided to expand these images of struggling nude men even further and created his "Gigantomachies," a series of five paintings, each of which measured at least ten feet high and by as much as twenty-four feet long.[45]

These ambitious works, executed between 1965 and 1968, affirmed Golub's desire to create an art that addressed concerns extending beyond the art world. Golub, who had openly criticized Abstract Expressionism, expanded the physical proportions of his paintings to those of the larger works by Jackson Pollock, Barnett Newman, and Robert Motherwell.

As he was to explain to Irving Sandler in 1968, "I came to state to New York that here is an art which has certain epic considerations which you must . . . face up to."[46] He also recalled at this time two powerful, large-scale paintings, Orozco's *The Triumph of Prometheus* and Picasso's *Guernica*, both of which had previously impressed him.[47] Indeed, about the latter, Golub had written:

Rhetorically, Guernica *might be viewed as a vehicle for disseminating "news," as the visual metaphor of a newspaper, a super-photograph or comic strip. It is "read" urgently, and the viewer is assaulted by the tumult and violence—the crowded, sensual, discordant and primitive ordering of ideas. Thus (like instances of the impact of exceptional news) the* Guernica *is stridently eloquent, tensely insistent on the reality of the events portrayed, utilizing the "news" to gain immediacy to re-enact the totality of the event as news.*[48]

The monumentality of the "Gigantomachies" also prompted Golub to begin working on unstretched canvas, which lent the paintings the feeling and presence of murals. He also increased the number of figures to depict a full-scale battle, as opposed to the earlier solo or paired figure compositions which could be interpreted as one-on-one altercations. The increased number of participants allowed Golub to comment on the nature of modern warfare and its potential for destruction.

For source material for *Gigantomachy III* (1966; Cat. 13), Golub turned to both the Hellenistic battling figures from the Great Altar of Zeus at Pergamon and to a sports photograph of rugby players (fig. 4). The latter, a highly charged masculine competition, itself a microcosmic arena signifying the conventions of struggle to defeat an opponent, is simultaneously more immediate and somehow more ungainly than the Hellenistic model. Yet Golub also intention-

fig. 4. Source photo for *Giganto-machy III*

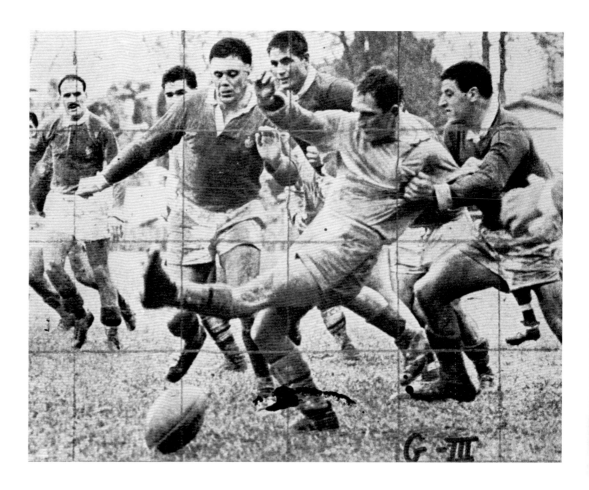

49 *Max Kozloff, "The Late Roman Empire in the Light of Napalm,"* Art News, *p. 60.*

50 *The "Gigantomachies" also share certain stylistic affinities with Antonio del Pollaiuolo's famous engraving,* Battle of Naked Men *(1465–70).*

ally moved away from the specificity of the individuals photographed, preferring instead anonymous, generic representations. As Max Kozloff wrote, "In order to be Everyman, the Golub hero finally has to be no one." [49]

In this series, Golub became increasingly interested in portraying the anatomical characteristics of these battling giants, using a black and white linear manner to articulate tendons and muscles. [50] He also shifted away from the depiction of contained, one-on-one battles between figures, and toward an insinuation that the figures were battling a force outside the pictorial space.

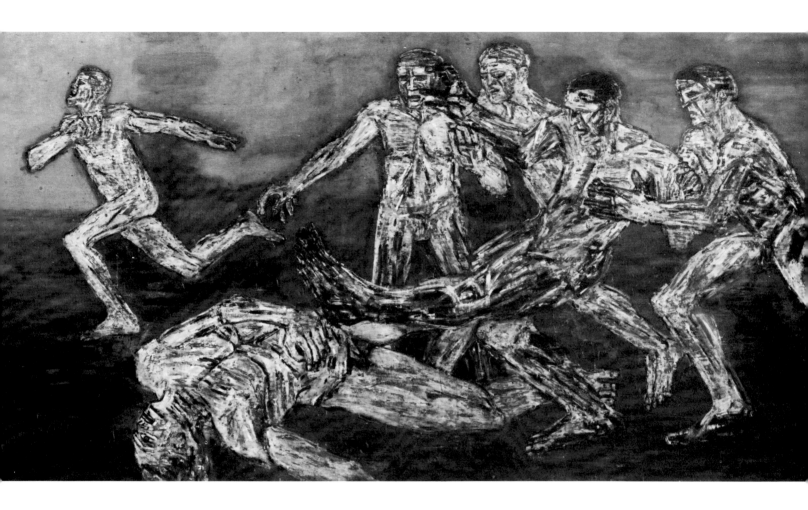

Catalog 13. *Gigantomachy III*,
1966. Acrylic on canvas,
114 × 212″. Collection of Ulrich
E. Meyer and Harriet C. Horwitz,
Chicago

A crucial painting that follows the "Gigantomachies" is *Napalm I* (1969; Cat. 14), a work Golub calls "an overt political effort."[51] As such, it holds a pivotal position in the artist's oeuvre. Now identifying the unspecified threat from which the giant nudes in the preceding series had fled, Golub depicts the effect of an invisible yet pervasive chemical enemy. The napalm, in a sense, thus represents the modern mechanism of depersonalized power. Golub, for the first time, unambiguously places his figures within the contemporary world, although the kneeling figure on the right is based on the Louvre's *Wounded Gaul* (250–200 B.C.), which Golub adapted from photographs. The other figure lies twisted, writhing in pain. The insidious effect of the chemical itself is suggested by the intense red area, adjacent to the fallen figure's face. The richly repulsive surface was achieved when Golub mixed into the red pigment collected scrapings from his other paintings. By literally stripping the paint off the canvas to reveal the weave of its fiber, he also formally and powerfully articulated the effect of the searing coagulation of the napalm on the figures' skin.

In 1972, Golub reworked a painting he had originally done in 1970 of two full-length, nude male figures recoiling from an unseen threat out of the pictorial space on the right. He cut a small triangular notch out of the canvas and added some dark lines that appeared to be moving across the surface of the painting, calling these "bullet trajectories." He did not, however, refer to a specific time frame. *Assassins II* (1970–77), as it was named, serves as a link between the many double figure compositions before, during, and after the "Gigantomachies" and the subsequent works devoted to the Vietnam war.[52]

The device of cutting into the unstretched canvas, begun around 1970, accentuates the paintings' vulnerability and flatness. The unstretched canvases also recall the feeling evoked by the earlier *Damaged Man* and, in addition to the mural connotations, suggest hides or flayed skins. The device of cutting into and deleting areas of canvas also served a formal function of emphasizing certain areas of the composition.[53]

An additional result of this technique was that Golub was able to create new works from the cut-out pieces. *Napalm Gate* (1970), is one such work, and together with the accompanying "Pylon" and "Shield" series, represent the only period of non-figuration in Golub's work. These collaged pieces of painted canvas are abstract but also exist as two-dimensional substitutions for real architectural objects. They refer to primitive post and lintel building systems, evoking both the megaliths of Stonehenge and the portals of Southeast Asia. Similarly, the concurrent "Napalm Shields" (Cat. 18) were made as an ironic homage to pre-industrial warfare, when weapons were fashioned out of whatever resources were available.

51 *Newman, p. 4.*

52 *This painting was inspired by photographs of the Hungarian uprising, though the "bullet trajectories" may also recall the Kent State massacre of students in May 1970. In 1977 Golub restored a triangular notch to the cut-out area that he had removed earlier.*

53 *In a sense, this is the reverse of collage, whereby an artist can affix disparate elements onto a work. Golub's impulse to remove the field from the figure is tantamount to creating a sculptural mode for the painted image. In fact, the notion of cutting away is akin to carving.*

Catalog 18. *Shield IV*, 1972.
Acrylic on canvas, 91 × 51″.
Courtesy of the artist

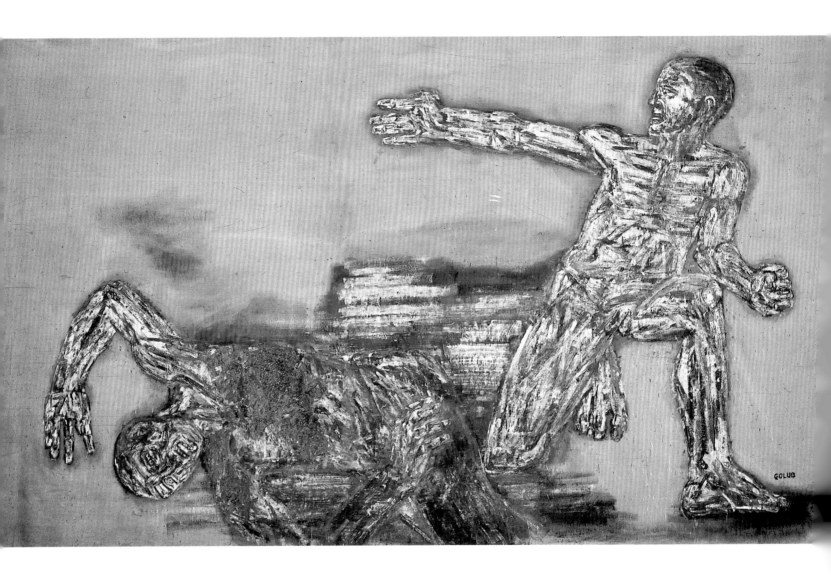

Catalog 14. *Napalm I*, 1969.
Acrylic on canvas, 116 × 198″.
Courtesy of the artist

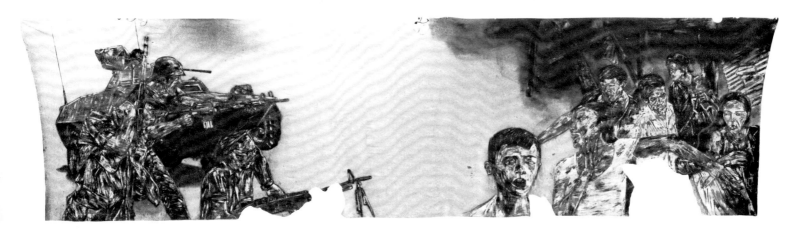

fig. 5. *Vietnam II*, 1973. Acrylic on canvas, 120 × 480". Courtesy of the artist

In 1968, commenting on his "Gigantomachies," Golub remarked

Why not be contemporary? Because I don't want to give the painting this kind of topical look. For example, if I make it a war picture, then I have to put a tank in it or I have to put them in uniform. I want it to be as universal and as timeless as I can make it. I want to get through to the metaphor of violence . . . I don't want it to be 1968 in Vietnam. I don't want to paint blacks. I want to paint the most generalized notion of man that I can under the most austere circumstances that I can and make it go. If I'm too specific then I'm caught in that particular moment. I don't want to be in 5th century Greece and I don't want to be in Vietnam. But I think it has reference to Vietnam in a certain way.[54]

By 1972, however, Golub changed his mind. That year saw Richard Nixon's landslide victory over the anti-war platform of George McGovern, the Watergate break-in, and Nixon's authorization of the mining of Haiphong harbor and the bombing of Cambodia. The "conflict over the specificity of the subject matter" that Golub was undergoing was resolved when he realized that his desire to unite his political convictions with the content of his paintings was an extension of his long-held belief in the primacy of subject matter.[55]

With this realization, an essential change took place in Golub's work. Instead of using the photographs of sporting events and antique sculpture as sources, he began to model figures in his paintings after news photographs of the war in Vietnam. As he focused on reportage rather than metaphor, Golub's evolution from the extreme subjectivity of the early 1950s to a more objective viewpoint came full circle.

54 *Sandler, p. 181.*

55 *Newman, p. 5.*

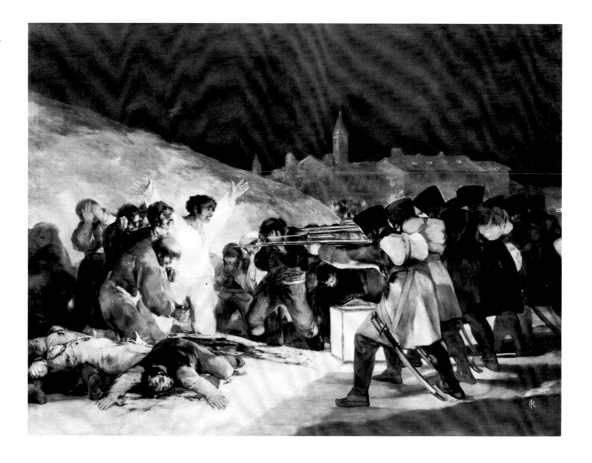

56 *Ibid., p. 4. Golub discussed how he changed the title of this series from "Assassins" to "Vietnam" "to emphasize location. As-sassins was never exactly appropriate and seemed to disproportionately accuse the soldiers rather than their leaders."*

At first he encountered difficulties with rendering clothing, so in *Vietnam I* (1972), the first of three paintings in this series, he left the soldiers stripped to the waist.[56] Automatic weapons make their first appearance in Golub's work in this gigantic (ten by twenty-eight feet) painting. The large cut-out area to the right brings to mind a ghostly presence of a large tank, and the rawness of the canvas had never before been so dramatically utilized.

Vietnam II (1973; fig. 5) is Golub's largest work to date. Extending a full forty feet in width, the canvas is divided into two sections: the American aggressors on the left and the Vietnamese victims on the right. The tank and uniforms that were unacceptable to the artist in

1968 are now fully depicted. And for the first time, Golub has brought the agents of power into direct confrontation with their victims. This work is reminiscent of Francisco Goya's *Third of May 1808* (1814; fig. 6), which expressed that artist's moral outrage over the Napoleonic invasion of Spain and the massacre of his countrymen. Similarly, Golub has used weapons to convey senseless slaughter by directing the viewer's attention to the victims, as if to implicate the audience as unwilling spectators. But whereas Goya's protest was along national lines, Golub's work is an indictment of the imperialism of his own country. Moreover, the emptiness of Golub's space is markedly different from Goya's scene, which refers to the site of a particular event in history. Golub has attempted to generalize the newspaper photographs by removing them from their original context.

The last work of the series, *Vietnam III* (1974; Cat. 19), creates a complicated psychological effect, achieved in part by the sense of isolation among the figures, each of which was taken from different photographic sources. The emphasis here is not so much on the questionable American policies of aggression, as seen in the highly charged attack scenes of the two previous works, but rather on the numbing aftermath – the defoliated landscape, the callous and deadening effect of war on the survivors, and to the irreversible loss of human life. The distinct representation of individual faces in varying states of shock or resignation poignantly alludes to a Pyrrhic victory which inevitably engenders vulnerability.

Golub experienced a letdown after completing this epic anti-war series, later claiming that "the work from 1974–76 . . . was lousy."[57] At a loss for direction, Golub noticed that the central soldier in *Vietnam III* reminded him of a young Gerald Ford, who had just been installed in the vice-presidency by Richard Nixon when Spiro Agnew was forced to resign. Golub regarded Ford as a somewhat sympathetic character who wavered between being a dangerous political force and a clumsy, inarticulate "good guy." Intrigued by the ambivalence of Ford's image, Golub decided to paint a portrait of Ford, based on his media persona.

In addition, Golub wanted to follow through on the depiction of the soldiers in *Vietnam III* as victims of an unspecified political power. Whereas this soldier may have resembled Gerald Ford, someone in Ford's position would never allow himself to be seen in such a state of psychic exhaustion. Golub thus set out to explore the "face of power" – those who decided the fate of the dogface G.I. Joes.[58] Often larger than life, these heads are conceptually related to an older series of heads begun in the late 1950s, as well as to the brutally realistic portrait busts of citizens of the late Roman Republic.[59]

Armed with a new theme, Golub began what turned out to be an extended series of

57 *Ibid., p. 5.*

58 *Ibid.*

59 *Since his years in Italy, Golub had worked on paintings of large-scale heads as a subgroup. In fact, his interest in depicting skulls dates back to his student years.*

Catalog 19. *Vietnam III*, 1974.
Acrylic on canvas, 120 × 336″.
Courtesy of the artist

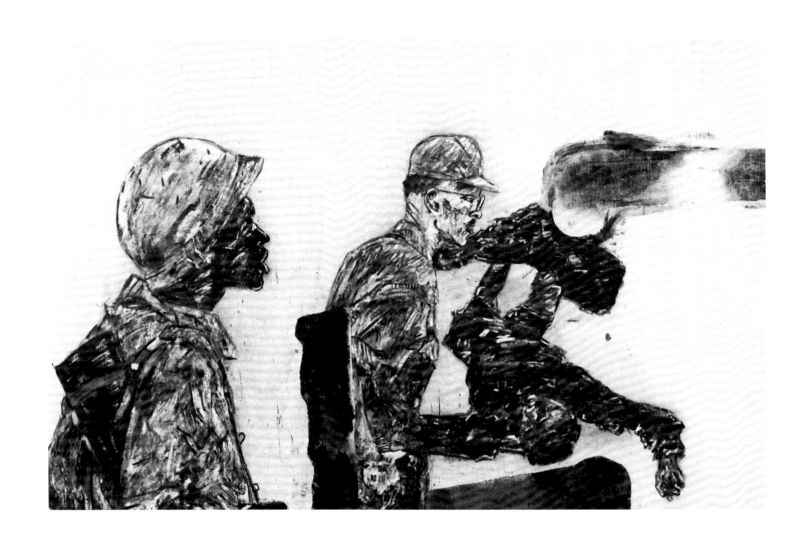

Catalog 19. *Vietnam III* (detail; left side)

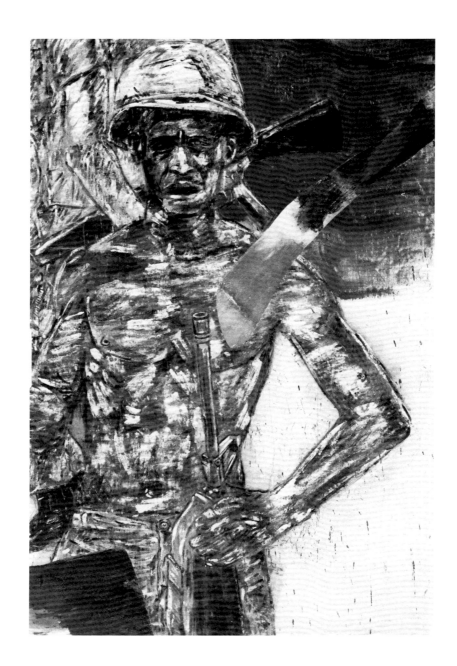

Catalog 19. *Vietnam III* (detail)

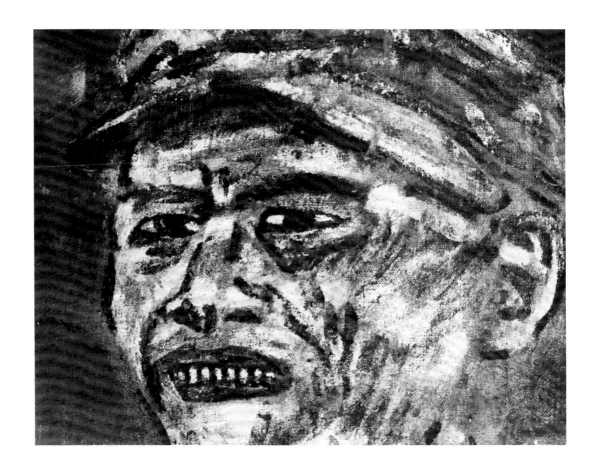

Catalog 19. *Vietnam III* (detail)

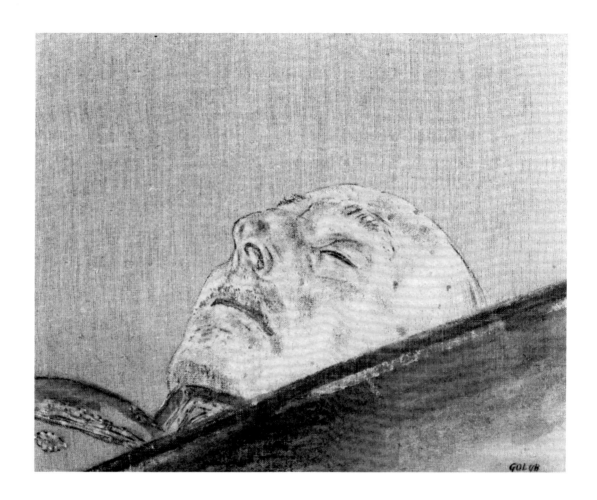

Catalog 22. *Portrait of Franco*,
1976. Acrylic on canvas,
18 × 23″. Collection of Ulrich E.
Meyer and Harriet C. Horwitz,
Chicago

paintings, which he worked on from 1976 to 1979. During these three years, he produced more than 100 portraits of various male power figures, the priests and shamans of our post-industrial world, including Supreme Court Justice William O. Douglas, AFL-CIO president George Meany, former secretaries of state Henry Kissinger and John Foster Dulles, and former Philadelphia Mayor and Police Chief Frank Rizzo. In addition to the Americans, Golub portrayed Yasir Arafat, Leonid Brezhnev, Fidel Castro, Ho Chi Minh, Zhou Enlai, and Mao Zedong, among other political and religious leaders. At first Golub worked solely from photographs culled from newspapers and weekly magazines, but as he became more deeply involved, he rented material from photo agencies.

The seven paintings of Nelson Rockefeller form a cumulative portrait. The study of the young Rockefeller reveals a tightness of character and a resolute ambition, as well as a touch of sadness in the eyes (Cat. 25). Another depicts Rockefeller earnestly debating, his brow furrowed, his teeth clenched, while his lips are pursed, frozen by the unyielding distortion of the fraction-of-a-second shutter speed of a camera (Cat. 26). We also see him, pensive, during a moment of private reflection in a public light, revealing a more introspective side to his character.

In another painting, we see the stoic face of a man humbled by the mysterious loss of his son in New Guinea. His advancing age is visible, as is the bitterness of rejection, of never having received his political party's nomination for the presidency (Cat. 29). Also discernible is the arrogance of the man who misjudged the prisoners' demands during the Attica prison uprising, thereby precipitating that horrific massacre. Golub has enhanced the data available in the news photographs, investing it with pathos via his painting technique. The scraped-away paint leaves an emphatically flat, ghostlike image, and these portraits ultimately reveal the challenges of living a life under the obdurate gaze of the public. Moreover, since they were not commissioned by the subject, no compromises were made. Golub condenses the process of aging into five separate moments in his series of the late Generalissimo Franco — a man who stood in polar opposition to the artist's personal politics and was directly responsible for the 1937 Guernica bombings. The image of the dead dictator lying in a casket is a stirring essay demonstrating the ultimate subjection of worldly power to death (Cat. 22).

In the spring of 1979, Golub returned to his monumental format in a series of "Mercenaries." [60] Here, he focused on those who carry out the policies of the leaders he had portrayed during the previous year and a half. With this series, Golub reverted to an unspecified locale, but now the figures are as clearly articulated and individuated as the soldiers in

60 *In 1976, previous to the portraits of world leaders, labor union chiefs, and heads of churches, Golub had undertaken large scale paintings of mercenaries. He deemed them unsuccessful, saving one and subsequently cutting up another into four sections.*

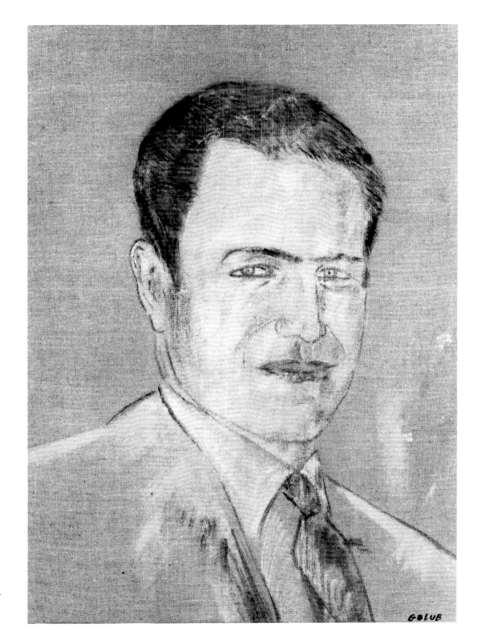

Catalog 25. *Portrait of Nelson Rocke-*
feller, 1976. Acrylic on canvas,
23 × 18″. Courtesy of the artist

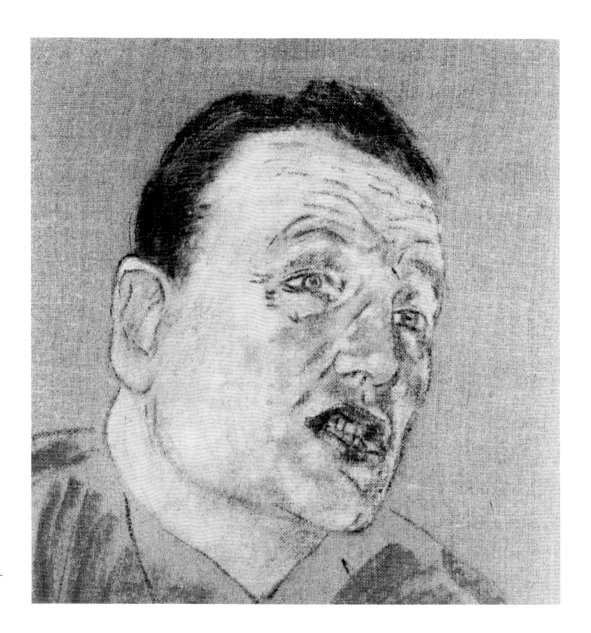

Catalog 26. *Portrait of Nelson Rocke-feller*, 1976. Acrylic on canvas, 14 × 14″. Courtesy of the artist

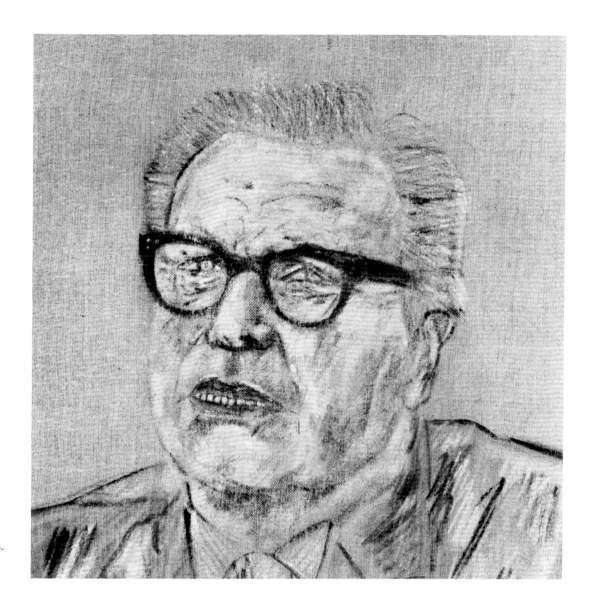

Catalog 29. *Portrait of Nelson Rocke-feller*, 1976. Acrylic on canvas, 17 × 17". Courtesy of the artist

the "Vietnam" paintings. Moreover, their clothing and arsenal clearly identify them as the soldiers of fortune of the 1970s and '80s. Since "mercs" have had plenty of opportunities for employment in recent years, we can only guess at the exact location. Golub has thus arrived at a powerful balance between the specific and the universal.

In *Mercenaries I* (1979), three three-quarter-length frontal standing figures are set off against an empty ochre background of the unprimed, Belgian linen that Golub has used for many years. The figures are shown brandishing their automatic weapons in various ways, each looking out of the pictorial space, establishing eye contact with the viewer. The uneasiness of their stances suggests that they are posing, "as if they're having their photograph taken."[61] Yet the enormous vitality and animation evident in their faces is far greater than in the earlier portraits of the political leaders.

In the second painting of the series, *Mercenaries II* (1979; Cat. 32), Golub introduced a new formal element which enhanced the curious relation between the figures and the ground, as well as their relation to the viewer. Rather than placing the figures against the passive and neutral unstretched linen, Golub flooded the background with a flat red oxide, heightening the sense of imminent violence. Golub notes, "The red oxide backgrounds recall the public walls of Roman art and force the mercs and interrogators forward into our space."[62] Indeed, the larger than life-size figures, which are emphatically scraped but carefully worked to create an illusion of substance and weight, appear to leap out from the flat, unreal space of the unmodulated background. Golub comments further on the uneasy relationship of the audience and the figures in his paintings:

> The mercs are inserted into our space and we're inserted into their space. It's like trying to break down the barriers between depicted and actual space, the space of the event. To be inserted in the paintings means forcible contact.[63]

Violence is implied everywhere: in the artist's use of the red background suggesting blood and in his scraping technique (for which he now employs a meat cleaver), as well as, more obviously, in the subject matter. The violence continues in the cropping of the figures' legs along the bottom edge of the painting and with the disjunctive spatial flattening that occurs because the middle figure's leg is obliterated by his colleague to the right. While Golub has positioned the viewer as a voyeur in this scene, the one mercenary who appears to gaze out toward the viewer's space is wearing dark glasses which, in combination with the gaps in his teeth, give his head the appearance of a skull (Cat. 32; detail). Thus, it isn't certain whether

61 *Newman, p. 4.*

62 *Ibid., p. 10.*

63 *Ibid., p. 4.*

the viewer is free to watch or if, conversely, the viewer is the subject of the mercenary's voyeurism.

Golub has also charged the large expanses of vacant space among the figures with a psychic presence, a device he had exploited in the "Vietnam" paintings. In *Mercenaries IV* (1980; Cat. 33), a void separates the two groups of figures in a composition similar to the earlier *Mercenaries III* of the same year. In the later work, the space is animated by a playful hostility between the black man at the far left as he taunts the husky fellow on the right, suggesting violence not only among the mercs and their enemies, but also between themselves. Apparently, the mercenary, despite his prodigious physique and the most updated weaponry, is still vulnerable to his colleague's verbal assaults. As Golub has noted, "It's a moment of relaxation – the [carnage] has stopped and they're joking around." [64]

Golub's depiction of what he calls "the lumpen type of mercenary who takes on these jobs for 500 bucks a month and enjoys the fun and games" has other implications as well. [65] In 1982, Golub noted that:

Mercenaries sprout at the peripheries when governments or agencies are reluctant to use the central or public organs of control, when one takes overt action indirectly or irregularly. And because they're edged away, irregular actions can be both fuzzy or paradoxically discernible. [66]

In an indirect way, Golub has indicated a certain identification with his subject matter. Discussing responses to the "Mercenaries," Golub suggests that the viewer identifies with the mercs, therefore implicating himself:

One claims to support humanist values, liberal points of view. But maybe on some level you're identifying with those guys, deriving a vicarious, imaginative kind of pleasure in viewing these kinds of macho figures. . . . [67]

Golub has also pointed out that power has a distinct social structure, beginning with the *capo*, literally "head" or chief. The mercenary is one rung on a power ladder little known to the public. Moving up the ladder in the bizarre underworld of terror and torture, Golub's next series focuses on interrogators. He notes:

The interrogators are . . . functionaries and their manners and gestures are different. I try to characterize gestures or appearances which would make them more "civil," brutal as they are, because

64 *Ibid. The interview as published reads "courage" rather than "carnage." Golub has noted that this was a typographical error.*

65 *Ibid., p. 8.*

66 *Ibid., p. 11.*

67 *Ibid., p. 7.*

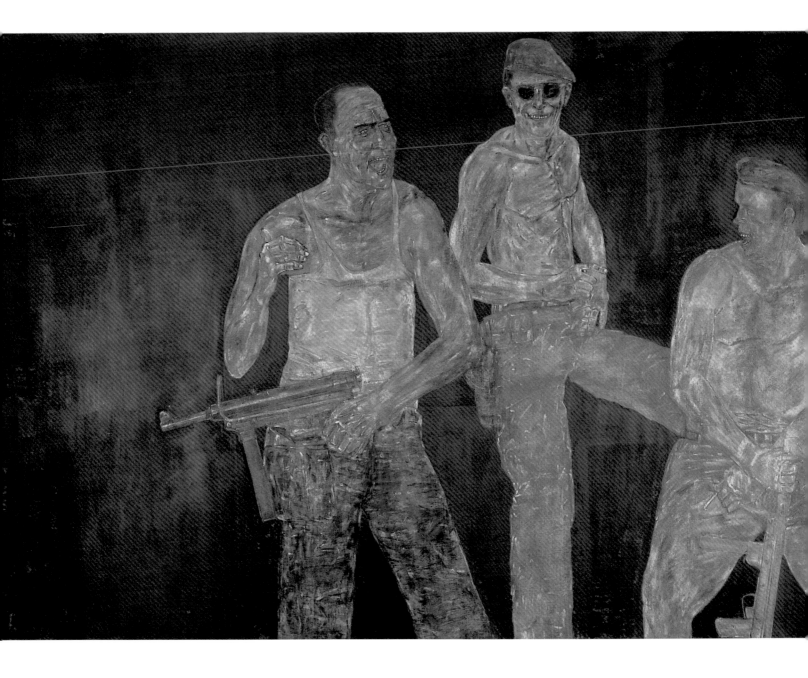

Catalog 32. *Mercenaries II*, 1979.
Acrylic on canvas, 120 × 172".
Collection The Montreal Museum
of Fine Arts; Purchase Horsley and
Annie Townsend Bequest

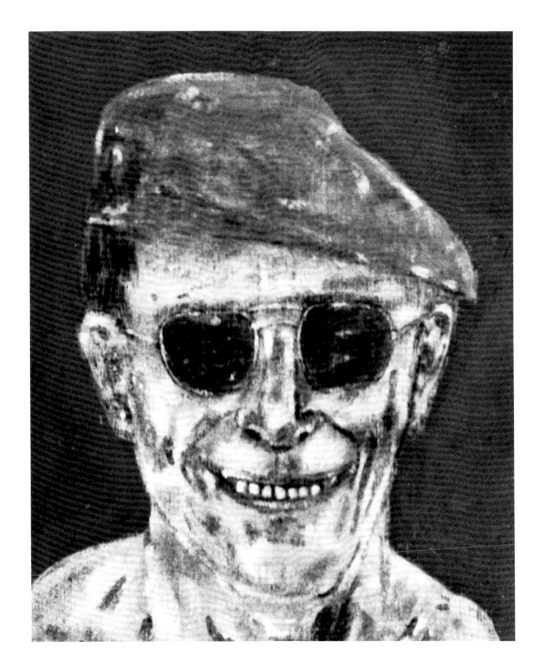

Catalog 32. *Mercenaries II* (detail)

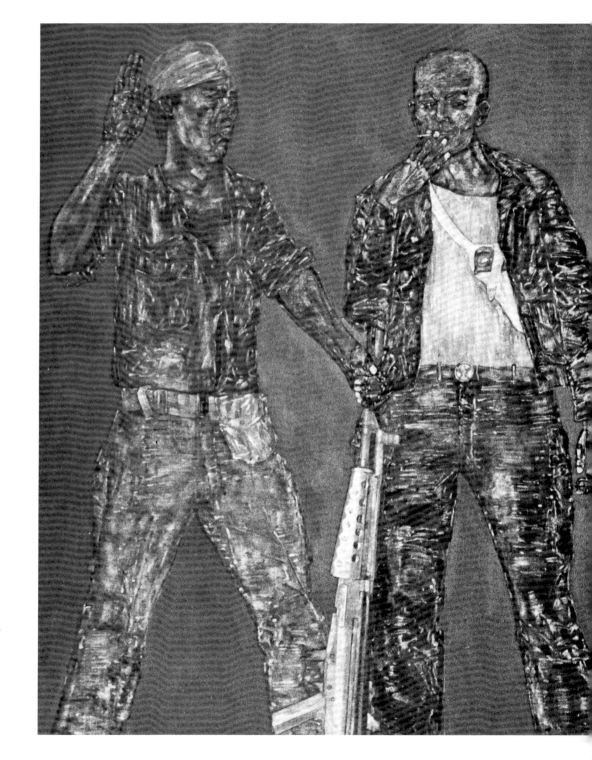

Catalog 33. *Mercenaries IV*, 1980.
Acrylic on canvas, 120 × 230″.
Collection of Doris and Charles
Saatchi, London

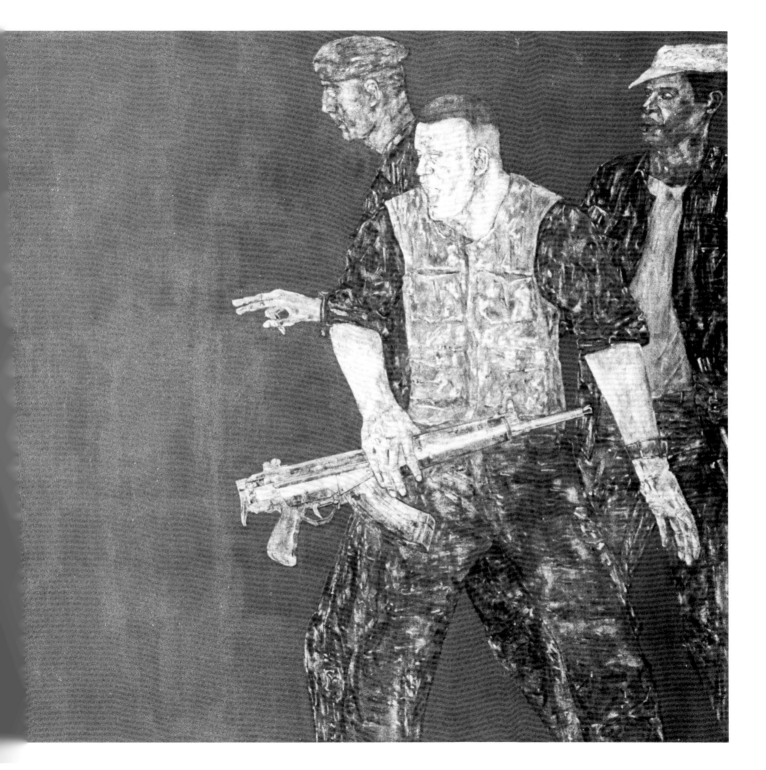

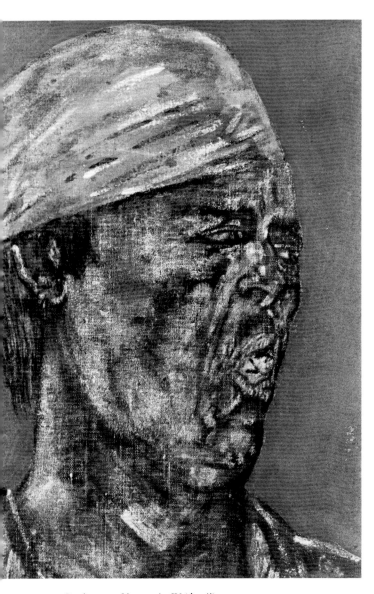

Catalog 33. *Mercenaries IV* (detail)

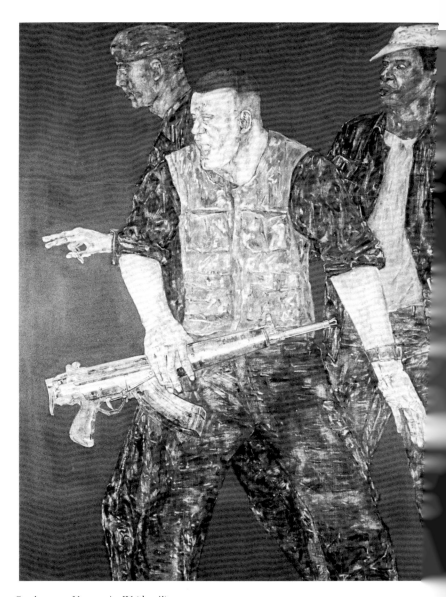

Catalog 33. *Mercenaries IV* (detail)

fig. 7. *Interrogation I*, 1981. Acrylic on canvas, 120 × 176". Courtesy of the artist

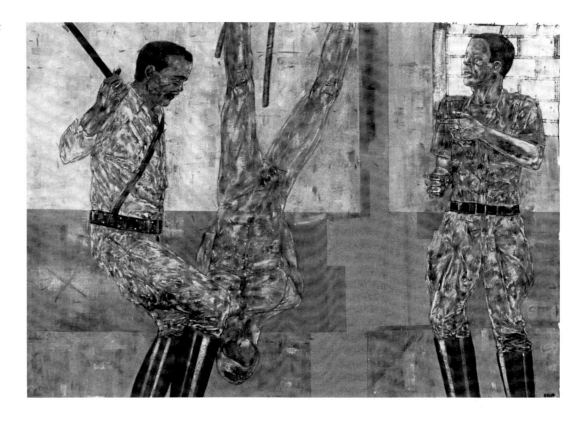

this guy has to report to someone else and has to know the forms of social discourse when he talks to his captain because he's only a sergeant. . . . These are the guys the people who run society can call upon to do their dirty work. Ultimately they're manipulated, also raw material for the machine, but for the moment they have their privileges.[68]

The three paintings of the "Interrogation" series were all executed in 1981 and depict perpetrators involved in various forms of physical abuse of victims who are gagged, bound, blindfolded, or suspended by their heels. Beyond the paintings' overt political content, Golub is actively assuming the role of the interrogator vis-à-vis his viewer. This is made even more explicit by the direct eye contact the artist forces between the interrogators and the viewer. Golub not only poses questions about witnessing such heinous acts, but about the viewer's possible passive complicity. As Jon Bird has pointed out:

68 *Ibid., pp. 8–9.*

fig. 8. *White Squad II*, 1982.
Acrylic on canvas, 120 × 187".
Courtesy of the artist

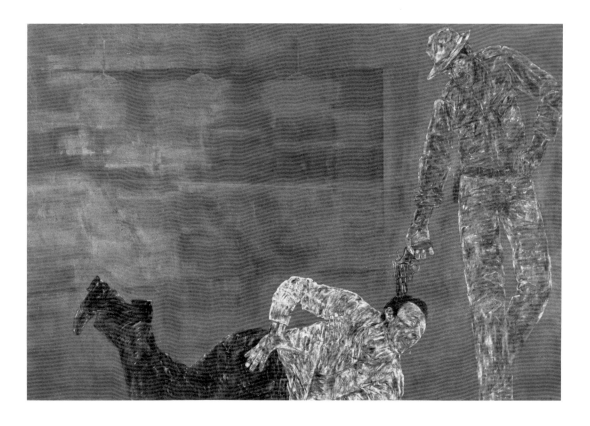

These paintings help make us aware that looking is not a neutral process but is invested with the psychic and social determinants of the subject's history and formation.[69]

The viewer, while standing before *Interrogation I* (1981; fig. 7), experiences a strange physical need to identify with the vertical and upright figures flanking the inverted figure, despite the fact that the one on the left swings a stick at the helpless victim. As in the case of Marsyas about to be flayed by Apollo, the man's nudity creates in viewers the disconcerting need to align themselves with the clothed interrogators who are in control of the situation.

The following year, Golub initiated two series of paintings which, in many respects, expand upon the subjects of the two earlier groups. The "White Squad" paintings deal with the proliferation of acts of violence, committed by the police rather than the military. As Golub has said:

69 *Jon Bird, "Leon Golub: 'Fragments of Public Vision,'"* Leon Golub, *p. 17.*

70 *Matthew Baigell, "'The Mercenaries': An Interview with Leon Golub,"* Arts Magazine, *p. 167.*

71 *Golub has alluded to his appreciation of Michelangelo, specifically the paintings in the Sistine Chapel. He was especially impressed by the Prometheus figure on the ceiling as well as the so-called "flayed self-portrait" that appears in "The Last Judgment."*

72 *Leon Golub, unpublished manuscript, 1984.*

73 *Newman, p. 6.*

74 *The conjunction of the assassin's gun and the obscured head of the dead man, coupled with the paranoid stare back over his shoulder is carefully orchestrated by the artist. Even the replacement of the victim's removed head with the unconscious visual pun on the colloquial phrase "giving head," adds to this lurid effect. Golub denies any conscious play, but adds that he is often aware of the phallic nature of the holsters or clubs, in addition to the more obvious guns, which these men hold. Moreover, when asked about the subtle sexuality in this painting, he remarked that he was focusing on the tight pants the assassin was wearing and the erotic implications of his buttocks, unaware of the conjunction of the figure's front with the dead man's head.*

In countries like Argentina and Chile, the police or elements of the armed forces change costumes at the end of the day's work and, in civilian garb, pick up enemies of the state. They supposedly operate in the daytime as regulars within official sanction. At night or in the early morning, they operate as irregulars.[70]

White Squad II (1982; fig. 8) represents the most succinct statement Golub has made concerning the relationship of power to vulnerability and the threshold between life and death. The awkward relationship of the two figures' legs, bent in pointedly different ways, creates a subtle *danse macabre*. The image seems a perverse play on Michelangelo's Sistine Chapel creation scene of God the Father giving life to Adam by means of the spark that invisibly arcs across the distance that separates their outstretched fingers.[71] Here, the revolver fills the gap between the assassin's hand gripping the weapon and the victim's head, futilely raised up for his last glimpse of his executioner.

Of *White Squad (El Salvador) IV* (1983, cover detail; Cat. 40), Golub has written:

The cop . . . turns around eyeing us as we interrupt the scene (or, as in some instances, smirks in mocking acknowledgment and complicity). The figure virtually says, "If I step off the canvas, watch out!"[72]

The artist's placement of the viewer in a precarious psychological relationship to the depicted scene has become the fundamental mechanism at work in Golub's most powerful paintings. He has noted:

I would like to think that these paintings have {a} sense of that immediacy, that contemporaneity of events. They are poised to be almost physically palpable, a tactile tension of events.[73]

The head, always central to Golub's imagery as a metaphor for the intellect and the imagination, becomes, in *White Squad II*, the point of mediation between one figure's power and the other's vulnerability. In *White Squad IV*, we witness a symbolic decapitation, which seems as if it takes place only moments after the trigger was pulled in the earlier work. The complex composition, in which the dead man's head is eclipsed by the murderer's body, provides a sadistic, sexual element.[74] It is not surprising, then, to learn that Golub found a few of his photographic sources for some of these later paintings in sadomasochistic magazines.

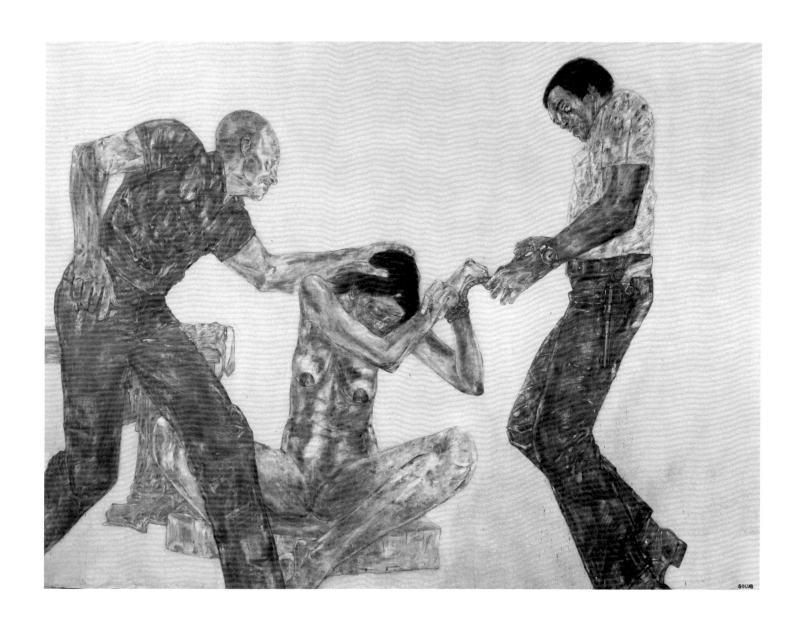

Catalog 35. *Interrogation III*, 1981.
Acrylic on canvas, 120 × 166″.
Collection of Paul and Camille
Oliver-Hoffmann, Chicago

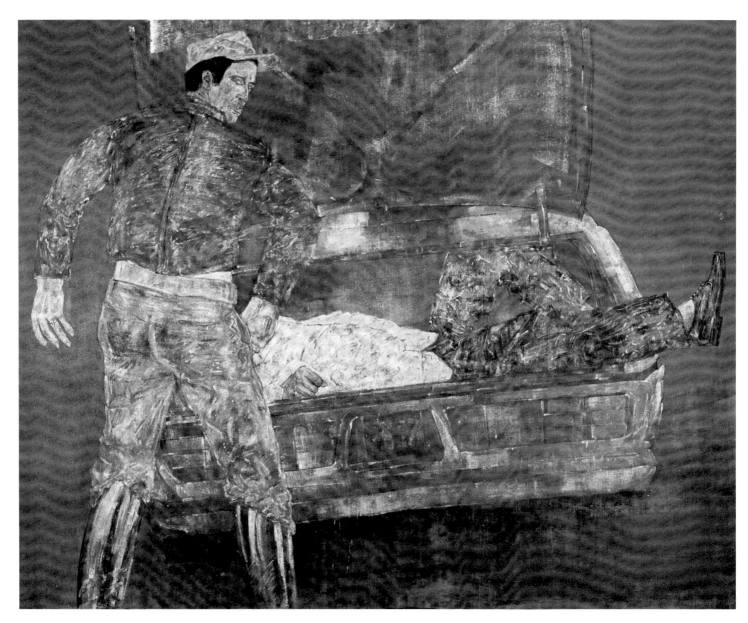

Catalog 40. *White Squad (El Sal-
vador) IV*, 1983. Acrylic on canvas,
120 × 152″. Collection of Doris
and Charles Saatchi, London

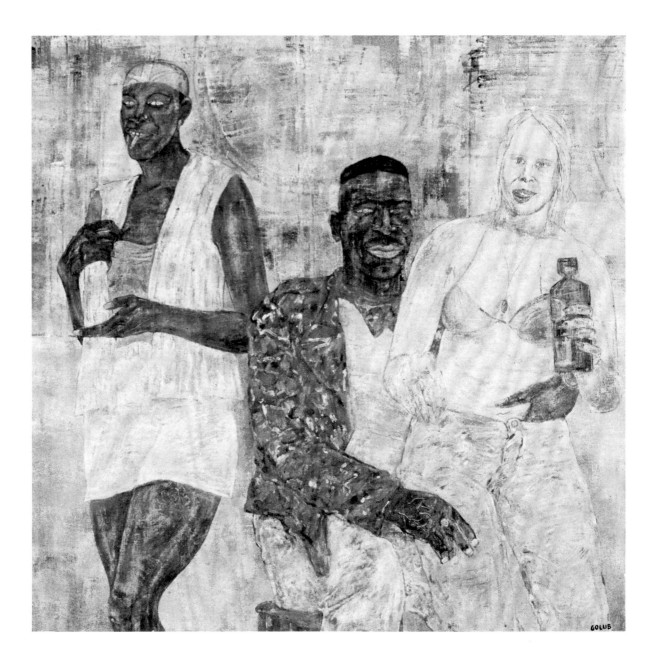

Catalog 38. *Horsing Around III,* 1983. Acrylic on canvas, 88 × 90". Collection of Eli and Edythe L. Broad, Los Angeles

This conflation of sex and violence becomes more explicit in the second series begun in 1982, "Horsing Around" (Cat. 38). The male mercenaries and interrogators are seen relaxing with their girlfriends.[75] This series, too, is confrontational, with direct eye contact between the painted figures and the viewers, but here the issue is the debasement of physical love. The depicted sexual play seems tantamount to the same license to violence or torture seen in the attitudes and demeanor of the mercs and interrogators in the earlier paintings. As Carter Ratcliff has written, "Here the power plays are sexual. . . . For Golub the hired gun's night off is a theater of the weird and the wired. . . ."[76] Appropriate to the theme, Golub has lightened his palette, ironically replacing the red background of the preceding series with pastel blues and pinks.

Golub's most recent series is entitled "Riot," portraying the moment when the assigned violence of the mercs and interrogators turns into a chaotic provocation. *Riot II* (1983–84; Cat. 39) echoes the same palette of the "Horsing Around" series, but features the most active aggression yet to be vented on the viewer. The red-haired woman's mouth is agape; looking like the Medusa, she screams with a wide-eyed frenzy. Behind her a bald-headed man, dressed in pale green pants and a yellow shirt and wearing sunglasses, cocks his fist and bites his lip with a perverse anticipation of violence. To his right, another man holding a club makes an obscene gesture with his left hand while engaged in a provocative challenge. All this energy converges on the viewer with inexorable force, and with little separation between the pictorial and real spaces. Golub's focus has shifted from a victim within the painted scene to the viewer as the potential target of the figures' rage and brutal inertia. As Golub has remarked:

> *There is a certain* ressentiment, *an aggressive shoving of these images right back at a society which tolerates these practices, which hatches them, like saying, "You're not going to evade this, you're not going to pretend this does not exist."*[77]

Golub has been increasingly concerned with the individual's private response to his art. He has pointed out that, despite their large size, his paintings are "not really public; I'm appealing to public awareness rather than making big public statements. These can only be fragments of a public vision, pulled apart."[78] The artist himself acknowledges that he plays a multiplicity of roles in creating the disjunctive experience he presents. Describing the various positions he occupies, Golub has claimed to be "the perpetrator, the victim, the voyeur, and the orchestra leader."

75 *With the exception of* Interrogation III, *this series reintroduces female figures into Golub's imagery, the first since 1957 and the last "Birth" painting. Golub has noted that he intended to suggest that some of these female figures could be transvestites.*

76 *Carter Ratcliff, "Theater of Power,"* Art in America, *p. 72.*

77 *Newman, p. 7.*

78 *Ibid., p. 6.*

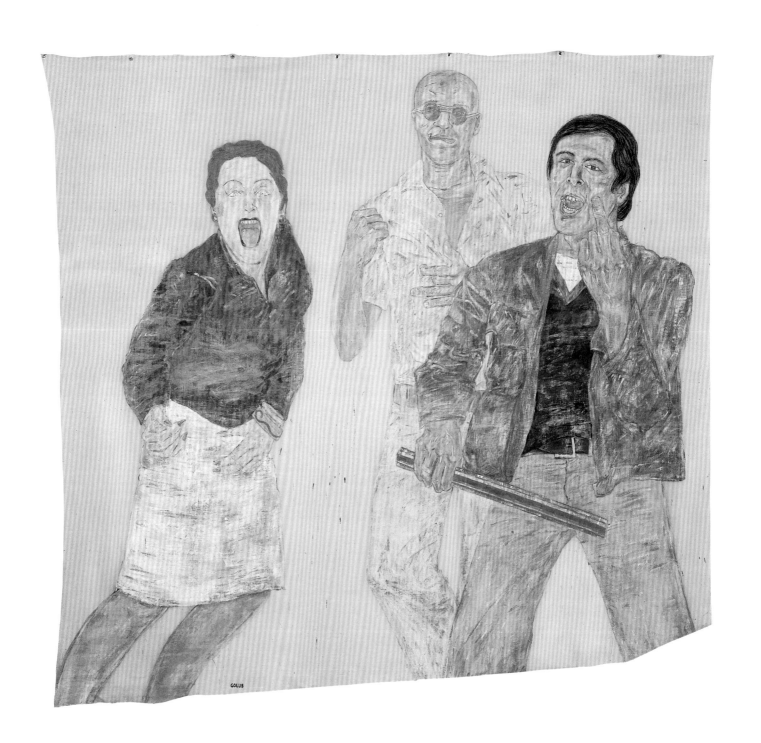

In his early work, Golub was inner directed, reflecting upon the nature of power in a prerational realm and employing distorted frontal male figures as mirrors of highly subjective, emotional self-portraits. Gradually, his viewpoint became more objective and he turned to classical sources as inspiration for a series depicting both the active (athletic) and the passive (philosophical) man. After 1956–57, the pivotal year he spent in Italy, Golub turned to photographs as source material, further objectifying his feelings and ideas. The photographs became increasingly important, owing to the manner in which they capture man in fractured moments of continuity. Golub, discussing the significance of what he has called the "splintering experience" of documentary photography, has pointed to its "iconic capacity," explaining:

> *Photography has changed our ways of seeing, changed our ways of separation, disjunction and conjunction, changed the way we recognize experience, and ultimately the way we see ourselves.*

In this sense, the mirror used to reflect the outer world upon the inner has been superseded by the photograph, that two-dimensional record of frozen time that sensitizes us to the disjunctiveness of contemporary life.[79]

Rather than exploiting art historical sources for iconographic content, Golub sought a more immediate frame of reference for his work of the 1960s, turning to sports imagery, which he adapted to the more universal theme of man in combat. With his "Vietnam" paintings, he shifted again, this time to images of the war. He combined several figures drawn from different photographs to create a sense of the insular individual as much shellshocked by the violence he has committed as by the direct experience of personal danger. In the series of political portraits, Golub depicted faces of these powerful men at various points in their lives in order to demonstrate the many facets of a public persona created by the camera and other conduits of mass media.

With the "Mercenaries," Golub began to use multiple photographic sources for each individual figure. This method of selecting bits of various disjunctive moments and overlapping them to form one figure—all the while scraping off the paint to leave behind a skeletal residue of animated imagery within a flat outline of a figure—allows Golub to depict what he calls "the face of the modern world," a composite portrait constructed from bits of photographic data.

Golub's insistence on the dramatically flat figures projected onto the "skin" of the unstretched canvas makes more sense when one considers the ramifications of this metaphor.

79 *There is also a coincidence between the violent subjects depicted in Golub's paintings and the orientation toward photography. Both the gun and the camera are aimed at a target and in both cases they are "shot." The use of the "shot" in photography is historically linked to Étienne-Jules Marey's rifle-shaped camera which yielded his "chronophotographs" in 1882. (See G.W. Ceram, Archaeology of the Cinema, New York: Harcourt, Brace & World, 1965, pp. 126–27.)*

Skin is the point where the inside and outside worlds literally come together and is also a vulnerable shield against personal violation. By violently cutting into or "eviscerating" the "skins" of the canvases, Golub evoked the fragility of the surface of both his painting and the viewer's own physical container.[80]

Another metaphor surfaces when examining Golub's oeuvre. Looking closely, one becomes aware that with some exceptions, his figures have been cut off at the shin. Given Golub's infatuation with photography (a medium whose essence involves the fixing of light and darkness) and his use of the opaque projector to throw enlarged images onto the unstretched "skins" of his canvases, the large figures act as shadows—flat projections of three-dimensional figures—which are fixed on the surface of the paintings. He has stated, "One of the things at the basis of how I'm working . . . is, at some level, the idea of the hero, anti-hero, the two sides, man and his shadow in a certain way."[81] Considering that one's shadow is one's unique, two-dimensional extension, Golub's figures take on additional significance. Golub presents these figures as both extensions of himself and of the audience, since when viewing the work we are placed in the same position as that of the artist.

Golub has also been interested in capturing the awkward, fragmentary moment, so that the paintings will resonate with that instantaneous seam between now and then, that time/space continuum from which we normally seek refuge, the "it-will-pass" feeling of fear and/or complacency. Golub has called this a "no-space":

> "No-space" is a spatial indicator of simultaneity, spaces with local differences but "mediated" simultaneously. This is the "now" space of contemporaneity and actions can occur virtually anywhere. This is how "news" is imprinted. . . . Abstract space frequently dissolves information.[82]

Golub urgently wants his viewer to dwell in the truth amid the fictions he creates, in hopes that he or she will defuse the "it's-only-a-movie" defense.

While his recent work is ostensibly concerned with abuses of power, the paintings are not political merely by virtue of what they depict. Rather, they are political in their aesthetic, which recreates the circumstances of seeing but not acting, thus addressing the question of ethics. In other words, the viewer is challenged to not surrender his or her power to the painting, in order to avoid becoming its victim. However, because they are in the end pictures—illusions, facsimiles, and abstractions—that are composites of the things they purport to represent, they are steadfastly intellectual and as such originate and function in much the same realm as does the will to act. As Golub surmises:

80 *Sandler, p. 149.*

81 *Ibid., p. 148.*

82 *Newman, p. 9.*

83 *Ibid., p. 11.*

It's as if breaking the limits of representation is a clue to breaking domination. Intervention, the possibility of action in the world is very evident. I see work as representing a radical potential for action. I don't know that I could claim such a figurative ideal! [83]

By creating flat, yet in so many respects sculptural, episodic tableaux, Golub has partaken of his art's very subject. He addresses power and its effect not only by depicting it, but by issuing it as an aesthetic strategy. Given the many definitions of the word "power," it appears that Golub is attempting to assess the ways in which we as individuals and he as an artist can come to terms with our need for power and the attendant responsibility to use it with restraint and purpose – what Golub identifies as "the question of sanction." But above all it is the first and fundamental definition of the word, the "ability to do or act," that is laden with dilemma. Since whenever power is exercised there is often a victim; so too the brighter the light, the darker the shadow.

Leon Golub working on *Mercenaries*
V, 1984

1. The Princeling, *1952*
Enamel and oil on canvas
48 × 32"
*Collection of Stephen S. Golub,
Swarthmore, Pa.*

2. Anchovy Man, *1953*
Oil and lacquer on canvas
40 × 24"
*Collection of Milton Brutten and
Helen Herrick, Philadelphia*

3. Siamese Sphinx I, *1954*
Lacquer on masonite
30 × 41"
*Collection of Fritzie Sahlins,
Chicago*

4. Damaged Man, *1955*
Lacquer on canvas
48 × 36"
*Collection of Gene Summers, Los
Angeles*

5. Birth III, *1956*
Lacquer on canvas
47 × 33"
*Collection of Philip S. Golub,
Wiesbaden, West Germany*

6. Orestes, *1956*
Lacquer on canvas
82 × 42"
*Collection of Lori and Alan
Crane, Chicago*

7. Philosopher III, *1958*
Lacquer on canvas
80 × 40"
*Collection of Stephen S. Golub,
Swarthmore, Pa.*

8. Reclining Youth, *1959*
Lacquer on canvas
78¾ × 163½"
*Collection of the Museum of Con-
temporary Art, Chicago; Gift
of Susan and Lewis Manilow*

9. Horseman II, *1960*
Lacquer and oil on canvas
81 × 93"
*Collection of Gene Summers, Los
Angeles*

10. Burnt Man IV, *1961*
Acrylic on canvas
45 × 61"
Private Collection

11. Combat I, *1962*
Acrylic on canvas
92 × 81"
*Collection of Gene Summers, Los
Angeles*

12. Head I, *1963*
Acrylic on canvas
46 × 39"
*Collection of Wayne Andersen,
Boston*

13. Gigantomachy III, *1966*
Acrylic on canvas
114 × 212"
*Collection of Ulrich E. Meyer
and Harriet C. Horwitz,
Chicago*

14. Napalm I, *1969*
Acrylic on canvas
116 × 198"
Courtesy of the artist

15. Assassins II, *1970–77*
Acrylic on canvas
98 × 72"
Courtesy of the artist

16. Napalm Gate, *1970*
Acrylic on canvas
126 × 81"
*Collection of Nancy Spero,
New York*

17. Shield, *1972*
Acrylic on canvas
91 × 53"
*Collection of Stephen S. Golub,
Swarthmore, Pa.*

18. Shield IV, *1972*
Acrylic on canvas
91 × 51"
Courtesy of the artist

19. Vietnam III, *1974*
Acrylic on canvas
120 × 336"
Courtesy of the artist

20. Portrait of Franco, *1976*
Acrylic on canvas
16 × 16"
Collection of Ulrich E. Meyer and
* Harriet C. Horwitz, Chicago*

21. Portrait of Franco, *1976*
Acrylic on canvas
18 × 16"
Collection of Ulrich E. Meyer and
* Harriet C. Horwitz, Chicago*

22. Portrait of Franco, *1976*
Acrylic on canvas
18 × 23"
Collection of Ulrich E. Meyer and
* Harriet C. Horwitz, Chicago*

23. Portrait of Franco, *1976*
Acrylic on canvas
21 × 17"
Collection of Ulrich E. Meyer and
* Harriet C. Horwitz, Chicago*

24. Portrait of Franco, *1976*
Acrylic on canvas
17 × 18"
Collection of Ulrich E. Meyer and
* Harriet C. Horwitz, Chicago*

25. Portrait of Nelson
** Rockefeller,** *1976*
Acrylic on canvas
23 × 18"
Courtesy of the artist

26. Portrait of Nelson
** Rockefeller,** *1976*
Acrylic on canvas
14 × 14"
Courtesy of the artist

27. Portrait of Nelson
** Rockefeller,** *1976*
Acrylic on canvas
30 × 24"
Courtesy of the artist

28. Portrait of Nelson
** Rockefeller,** *1976*
Acrylic on canvas
22 × 18"
Courtesy of the artist

29. Portrait of Nelson
** Rockefeller,** *1976*
Acrylic on canvas
17 × 17"
Courtesy of the artist

30. Portrait of Nelson
** Rockefeller,** *1976*
Acrylic on canvas
22 × 19"
Courtesy of the artist

31. Portrait of Nelson
** Rockefeller,** *1976*
Acrylic on canvas
18 × 17"
Courtesy of the artist

32. Mercenaries II, *1979*
Acrylic on canvas
120 × 172"
Collection The Montreal Museum
* of Fine Arts; Purchase Horsley*
* and Annie Townsend Bequest*

33. Mercenaries IV, *1980*
Acrylic on canvas
120 × 230"
Collection of Doris and Charles
* Saatchi, London*

34. Interrogation II, *1981*
Acrylic on canvas
120 × 168"
Collection of the Art Institute of
* Chicago*

35. Interrogation III, *1981*
Acrylic on canvas
120 × 166"
Collection of Paul and Camille
* Oliver-Hoffmann, Chicago*

36. Horsing Around I, *1982*
Acrylic on canvas
120 × 80"
Courtesy of the artist

37. White Squad III, *1982*
Acrylic on canvas
120 × 172"
Courtesy of the artist

38. Horsing Around III, *1983*
Acrylic on canvas
88 × 90"
Collection of Eli and Edythe L.
* Broad, Los Angeles*

39. Riot II, *1983–84*
Acrylic on canvas
120 × 172"
Courtesy of the artist

40. White Squad
** (El Salvador) IV,** *1983*
Acrylic on canvas
120 × 152"
Collection of Doris and Charles
* Saatchi, London*

41. Mercenaries V, *1984*
Acrylic on canvas
120 × 172"
Collection of Doris and Charles
* Saatchi, London*

1950 "A Law Unto Himself," *Exhibition Momentum – A Forum, 9 Viewpoints*, Chicago, Illinois

The contemporary artist is a law unto himself. His inverted, fragmented concept of reality rarely coincides with that of others.

Specialization, cultural discontinuity, and competing ideologies are context and fabric of our heritage. Art no longer speaks a common language. Content was formerly rooted in integrated meanings that were easily inheritable. Today the artist needs [to] seek for what he is to say – and to whom.

Peculiar to the contemporary artist is his conscious effort to seek those modes of thought and meaning that are to be the necessary symbolism of the time.

1955 "A Critique of Abstract Expressionism," *College Art Journal*

Abstract expressionism is an international style, perhaps the most generalized and widespread style that has appeared in this century. To what extent this style approaches anonymity – and paradoxically, in an extremely individualistic era, the intrinsic denial of individuated imagery – must be clarified in regard to the social role of the contemporary artist and any personal transcendence of general form expectations.

The writer would summarize the nature of abstract expressionism as follows:

1. the elimination of specific subject matters and a preference for spontaneous, impulsive qualities of experience.

2. the unfettered brush – discursive, improvisatory techniques – motion, motion organization, and an activized surface.

The artist substitutes for any normative sequence of concepts or experiences an impulse energy dramatized as "instinctual" to a pre-conscious state of mind. Actuality (purpose) is attained by abbreviated means through the "direct" impact of non-referential sensation. "Contact" becomes the meaning. Scratched, scribbled lines or ambiguous reality when the artist cannot cope with the contradictory stereotypes of the culture.

1956 *Leon Golub*, The Pasadena Museum of Art

I, myself, believe that we continue and enlarge the classic traditions of western civilization, the Greek humanist heritage. We are, however, members of a cosmopolitan but mass society, masters of great technological means but relatively unsure of the integration and orientation of

these techniques. This is an age of institutional change and crisis. We are beset by and conditioned through mass media whose over-simplified stereotypes remain oblivious to problems of integration, change and the advancing frontiers of knowledge. . . . As to the particular nature of my art: in making what I find necessary to make, I thus seem to (and thereby wish to) portray a cryptic, vehement, and often tragic image of man. This is not necessarily the "everyday" image but introspections into some aspects of a more ultimate realization of role. I admire Greek tragedy, such writers as Kafka and Joyce. I seek images perhaps powerful and awesome, at times eroded and isolated, perhaps anomalous – an ambiguity of tradition and the irrational that yet resonates of common experience.

1967 James A. Miller and Paul Herring, eds. *The Arts and the Public*

I'm very interested in the concept of distance because it seems to me that modern art is too close to us. Even if it's irreducible in many of its aspects, nevertheless you can accept it very easily. You can consume it as rapidly as you wish. This kind of consumption is in the viewer and the art simultaneously as a kind of existent pleasure or participant ground. One uses the word "field" a great deal in art discussions today. Field, environment, Happenings – these are all events and situations that involve you. You have to complete our work for us. Well, it isn't that I don't love you as much as anyone else, but I like the concept of distance. I want to throw up on the walls of our society paintings that you can't get close to. I don't want you to touch them. I don't want you to dance in front of my paintings. I don't want you to throw Kleenex at my paintings, you see. I want distance. I want something to happen which is rhetorical in the old sense of the word.

I am caught in a contradictory situation. I am dealing with certain existential realities such as brutality and violence. At the same time I want a public order in my work. I want something much greater and distant than myself, what I think is a measure of contemporary reality. Perhaps there is no public art. Perhaps there is no critical place – perhaps there is no criticism available to such an art. However, I as a painter claim to make a public art, and therefore I state, as artists always have, that in making such an art, that art exists. In fact, I insist on it!

"The Artist as an Angry Artist," *Arts Magazine*

Today art is largely autonomous and concerned with perfectability. Anger cannot easily burst through such channels. Disaffection explodes as a caricature, ugliness or insult and defamation – the strong disavowal of intellectuals and artists (comparable to French protests about Indochina and Algeria). Such anger today can only be made up of pieces of art, guises of art, gestures using art, habits, caricature, calumny, etc. This is not political art but rather a popular expression of popular revulsion.

1968 Unpublished interview with Irving Sandler. [Note: Parts of this lengthy interview were edited and published in *Arts Magazine*, 1970; *Journal, Archives of American Art*, 1978; and as "Opinions" in *Leon Golub: A Retrospective Exhibition of Paintings from 1947 to 1973*, Museum of Contemporary Art, Chicago, 1974.]

In a certain way the penultimate definition of realism is that it is the record that civilization keeps of itself. . . . I am trying to record certain things about power and stress, about this world of giganticism and automatic controls that we live in, but I'm trying to do it through an existential statement of where man finds himself in terms of these kinds of stress. The question is: who am I painting? Well I have this way of putting it: I'm painting citizens of our society, but I'm painting them through certain kinds of experience which have affected them. I can describe some of them – Dachau, Vietnam, automatized war, I would even say such a phrase as imperial America in a certain way. And I use those mechanisms which are available to me. For example, I use classic gestures a great deal. I have stolen many figures from classical sculpture. I change them a great deal but I copy them. I also take from war photographs and sports photographs. Many figures I make up. But the funny part is as I draw them, whatever the source, and they get a peculiar frozen quality which is almost like a paroxysmic fixity, influenced in a spiritual way by late classic art, for example, Pergamon.

1972 "Utopia/Anti-Utopia," *Artforum*

America is a big piece of the world today: perhaps America is the future viewed through technology and corporate extensions. The success images and dominance of American

modernism parallel general American dominance, and the "triumph" of American mobilization of art and energy resources. Since 1946 art speaks with an American voice and an American allure. These are arts of American power and affluence. . . .

Artists elaborate complex strategies and tactics under advanced capitalism and technology. Radical possibilities become defined (and finite) in a technological and corporate world view. According to its managers and users, technology is never gratuitous: technology embodies corporate decisions, the marvels of secure systems. Yet the very success of technology and the very fact of success breed irritability and frustration. Information is increasingly made available and totalized as part of the big open picture, but there are serious gaps. Information is continuously permutated and technologized: nonetheless, the supposed big view becomes surprisingly elusive and atomized. Modernist arts can be very solipsistic, nonevidential, and obdurate, that is, hard to connect to the information being continuously processed. Networks of data and technology develop excessive output or inhibit connection. In situations of totalized possibility, the artist may be reluctant to plug in to the massive data outputs of the big society. Reduction and minimalization are, in effect, both the result of the technologizing of information and, simultaneously, symptomatic of the artist's backing off from overloads, the noninformation side of the complex processings of the corporate state.

1973 "2D/3D," *Artforum*

Through technology occurs the flattening of the world, the compression (simultaneity) of the 3D world into flat impenetrable walls. Space is shoved up front, pulled taut in lateral directions directions over the "ground" of the canvas. Untarnished surface planes extruded by technology or that simulate such fabrication are wrapped around the surface of a flat world. The "wrap-around" is a tough surface skin. 2D surfaces possess many of the attributes of skin or membrane barriers: elasticity and/or inertness; porousness and/or surface resistance; qualities of rigidity, tension, or sag, etc. Skin is the membrane, the boundary, that links canvas and "world." (Clement Greenberg noted in 1949 that "the world was stripped of its surface, of its skin, and the skin was spread flat on the flatness of the picture plane.")

. . . . Western space becomes a big hole, an existential abyss. 2D covers the hole with flat spaces and flat colors. Space is compressed and sliced into 2D overlays which if flipped aside would reveal nothing other than an "infinite" series of such slices. Sculpture is more displacement of space than volume. For example, cubes are emptied out, made vacant, their substance voided, pumped out, or perhaps, scooped out (earth holes). Cubic formats can be

viewed as skins pulled rigid to form the object folded into cubic space. The cube, like the painting, is an "infinite" series of identical "laminated" surfaces; if one peels a sufficient infinite number of these identical nonexistent skins, one would arrive at a "final" skin, the flat wall of painting. If one could peel or skin minimal painting or sculpture and discard the peeled skins, they would resemble the inert scattered material of Process art. Such formats are "flattened" or transcendent. Time and space are vertiginous as modernism is reified toward the transcendental."

1977 *Profile: Leon Golub* [Note: Interview was conducted in 1977 by the Video Data Bank at the School of the Art Institute of Chicago, but not published until 1982.]

I finally came to the justification that at one level, I am simply a reporter. I report on these monsters because these monsters actually exist. This is not make believe; this is not fantasy; this is not symbolism. It is but it isn't. These situations which call these forces into existence actually exist. . . . My job is to be this machine that turns out these monsters at this particular point and make them tangible as possible. . . .

I don't think any artist can affect political change (although they can serve in the ranks). However, I think artists are unerring in their reflection of what is happening, what is possible. The kind of art you have at a certain time reflects the kinds of possibilities available both for the artist and for the general nature of society. And one can analyze the art on that basis, to what extent society is repressive. Partially repressive, to what extent we can move around. And each new art form defines this differently. But in terms of specific change, art doesn't initiate it but reflects any such changes. We know the Renaissance largely through its art. The future won't know the 20th century primarily through art but through technology, various media, etc. Yet the picture of the 20th century is going to be fantastically influenced by the art that we are looking at and that someone will be looking at 200 years from now.

1979 "What Works?," *Art Criticism*

Artists work in the interstices, the loose linkages, of the "system." Artists do not experience coercion (in the U.S. today) or overt pressure to conform (except the conformity of what is current, the "actual!"). The "superstructures" of corporate capitalism are sufficiently "liberal" and non-oppressive. Choice is part of the information explosion and is an aspect of the aggressive will or autonomous power ascribed to Western individualism. Prestige or financial

success reward artists whose performance can be successfully fixed to the "expected" unexpected art moves or limits. Does success cap the power of reproducing in art the tacit controls, contents, and technological efficiencies (the etherializations) of American power? An artist can reflect the radiation of American power even while "underground" since it is to the telos of American culture that art correlates to. . . .

The art market parallels and is synchronic to other markets of advanced industrial society. Each new success during the 50's and 60's as it reached intensive media/market attention spurred other developments, art capital accumulation, further spurring market information release and further accumulation. The artist as hero is not that different [sic] from the entrepreneur as hero, both viewed as powerful individualists who introduce new consumption codes, methodologies, or production processes. Art is a highly ordered product of the material forces at work. This is its surplus look, the etherialization of the high yields and consumption patterns of the West.

1981 Matthew Baigell. "'The Mercenaries': An Interview with Leon Golub," *Arts Magazine*

This is an American art. I am an American artist. I think that a powerful society, generally speaking, has a powerful art. It reflects not necessarily the goals of the society but, rather, the society viewing its strengths, how successful it is and what it can get away with. . . . The implications of confidence and the use of force are implied by these figures. . . . Over the years I have tried to objectify the nature of my work and these images are intended to be as objective as possible. What does this mean? Objective refers to correspondences to reality, to what is, to what occurs. Visual, perceptual objectivity locates identifiable references and is objective in recognizing correspondences, stipulated events, and political situations. Information access and communication is more simultaneous and speeded up than, say, 50 or 100 years ago. Because of speeded-up media access, our takes and reaction times are faster. Our perceptions have to accelerate in terms of the kind of processing that occurs through media, TV, newspapers, computers, things of this kind. I have in recent years used newspaper, photographs, and television and movies for the blatancy, for example, with which film projects images – how the scale of flesh, the scale of expression, is shoved at us in a flattening effect. This is particularly blatant in pornography. The freeze of a photographic gesture, the fix of an action, how an arm twists, how a smile gets momentarily stabilized or exaggerated – to try to get some of this is important. We have more variables, many more bits of information to deal with all the time. I attempt in these paintings to give some of the quality of media experience, a sense of tension

and of abrupt immediacy. The photofix inflects the almost literal shaping of a figure, changes of movement of potential movement, and a sense of occurrence or event.

1982 Michael Newman. "Interview with Leon Golub," *Leon Golub: Mercenaries and Interrogations*

I begin by projecting drawings or part of photographs onto the canvas – each figure is a synthesis of different sources. The drawing is evolved to precise details of dress, weapons, intention and so on. I want each figure to be both the reconstruction of a generic type and to possess an idiosyncratic singular existence. The figures are first outlined and shaded in black. The second coat emphasizes three dimensionality and designated highlights. I apply local colour to define skin, wood, metal, cloth. The canvas is put on the floor and paint areas are dissolved with solvent and scraped. The main scraping tool is a meat cleaver. Once the canvas has been scraped down, eroded – a process which frequently takes two weeks – I reconstruct the figures. I go on doing this, making adjustments. The paintings have a raw, porous appearance. . . . There is surprisingly little paint on the canvas; the forms and colours are smashed into the tooth of the canvas but, paradoxically, aggressively active on the surface. The final adjustments involve glances, all kinds of acknowledgments between these guys, to what extent I take them at face value, to what extent I parody gestures and looks. . . .

I disagree with that opinion that concludes that the newspaper or TV has devalued experience, that there is such a surfeit of photography and documentation that nothing has impact any more, that we're flooded and over-flooded with sensory confusion, that nothing stands out. It has been said, for example, that the images of Vietnam that appeared on American TV were devalued by advertisements, situation comedies, etc. I think the opposite. The very fact that the ads and the nightly news and all those things were on together bombarding people in their homes made it all the more horrific. All this atomized chaos, all the controlled and uncontrolled verbal and imagistic garbage jitters in the skulls of the onlookers even as it jitters in the skulls of the media manipulators. We're up against simultaneous bombardments from a range of media sources. I try to make some of these palpable in painting. The paintings are synthesized, made up from the flood of images that are knocking my head around. It's sensory confusion all right, but we obtain a pretty good notion of what it signifies and how it operates. The actions that I paint are incipient: they could take place under any society, under almost any circumstances. Political violence and political interrogation can happen anywhere. Part of the sensory jittering is that we know this although we often refuse to acknowledge the actions and appearance of domination.

Chronology

1922	January 23 – Leon Golub born in Chicago to Sara and Samuel Golub.
1930-34	Attends children's art classes at the School of the Art Institute of Chicago.
1934	Samuel Golub dies.
1934-35	Takes WPA art classes.
1935-38	Attends John Marshall High School, enrolling in standard art classes.
1938-40	Attends Wright Junior College, and develops an interest in late German Gothic wood crucifixes.
1939	Sees Picasso's *Guernica* (1937) on view at Chicago Arts Club; attends design, still life painting, and figure drawing classes at the Art Institute.
1940	Wins scholarship to attend the University of Chicago to study art history.
1942	Receives B.A. and starts master's program in art history at University of Chicago as Advanced Honor Scholar. Later that year, enlists in military service, working as a cartographer in England, Belgium, and Germany.
1946	Begins full-time study at the School of the Art Institute of Chicago.
1947	Returns to University of Chicago in summer to continue work on master's degree, but then leaves to attend art school full time. Early work includes a lithograph, *Charnel House* (1946), and the painting *Evisceration Chamber* (1947), comprised of expressionist imagery which evokes memories of the Holocaust. Begins Freudian analysis; meets Nancy Spero, also a student at the Art Institute.
1948	Interested in primitive art on view at Field Museum of Natural History. Helps organize the first "Exhibition Momentum," as an alternative to the Art Institute's Chicago Annual Juried exhibition when entrance is denied to students.
1949	Nancy Spero, while spending a year in Paris, sends Golub a copy of *Art Aujourd'hui* featuring art of the insane, reinforcing their strong interests in such "archaic" art making.
1950	Serves as chairman for "Exhibition Momentum," writing "A Law Unto Himself" for the catalog. Receives MFA; has first solo exhibition at Contemporary Gallery, Chicago. Starts teaching art at Wright Junior College.
1950-55	Completes psychoanalysis. Marries Nancy Spero. First experiments with scraping technique; begins "Priest" and "In-Self" series.

1952	Has first solo show in New York at George Wittenborn & Co. (prints only).
1953	Son Stephen is born; begins "Birth" series; starts teaching at University College, Northwestern University, Chicago.
1954	Selected by James Johnson Sweeney to be included in "Younger American Painters," at the Solomon R. Guggenheim Museum; first solo show of paintings at the Artists Gallery, New York; becomes affiliated with Feigl Gallery, New York. Son Philip is born.
1955	Affiliates with Allan Frumkin Gallery in Chicago; is fired from Wright Junior College "for defending modern art!"
1956	Scraping technique now used exclusively. Golub and Spero move family to Italy; reinforces strong interest in Etruscan and Roman art. Solo exhibitions at Pasadena Art Museum and Pomona College in California, where he sees Orozco's mural, *Triumph of Prometheus*.
1957	Lawrence Alloway organizes first solo European exhibition at London's Institute of Contemporary Arts. Begins "Athlete" series and uses photographs of classical sculpture as a primary source for these paintings.
1957-59	Teaches at Indiana University, Bloomington.
1958	Begins "Philosopher" series and colossal heads based on late Roman art.
1959	Selected by Peter Selz to be included in "New Images of Man" exhibition at MoMA, New York.
1959-64	Lives in Paris.
1960	Begins second "Burnt Man" series (first series in 1954). Exhibition in Paris at American Cultural Center; receives Ford Foundation Grant.
1961	Son Paul is born.
1962	Solo exhibitions at Galerie Iris Clert, Paris and Hanover Gallery, London; switches from lacquer to acrylic paint; begins "Combat" series. Receives Watson F. Blair Purchase Prize, 65th American Exhibition, Art Institute of Chicago.
1964	Returns to United States to live in New York. Begins participating in "Artists and Writers Protest" against U.S. involvement in Vietnam war. Retrospective exhibition, Stella Elkins Tyler School of Fine Art, Temple University, Philadelphia.

1965	Begins "Gigantomachy" series.
1965-66	Teaches at Stella Elkins Tyler School of Fine Art.
1966-69	Teaches at School of Visual Arts, New York.
1966	"Artists Peace Party" held in a SoHo loft is raided by police, ending up in a night march to City Hall and three subsequent minor court cases. Helps organize New York contributions to Los Angeles peace tower.
1967	Participates in "Angry Arts Week"; *Collage of Indignation* exhibited at New York University. Receives Cassandra Foundation grant.
1968	Unsuccessful effort to get Picasso to withdraw *Guernica* from Museum of Modern Art, New York, as an anti-Vietnam war protest. Receives Guggenheim Foundation grant.
1969	Begins "Napalm" series.
1970-present	Teaches at Rutgers University, New Jersey.
1970	Participates in some actions of "Art Workers Coalition."
1972	Begins *Vietnam I*, with first overt use of weaponry and uniforms.
1973	Receives award from American Academy of Arts and Letters, National Institute of Arts and Letters.
1974	Works on Chile mural reconstruction, West Broadway, New York; retrospective of paintings at Chicago's Museum of Contemporary Art, traveling to the New York Cultural Center in 1975.
1976	Completes first "Mercenary" painting.
1976-79	Paints political portraits. In summer 1979, returns to "Mercenary" theme.
1982	Solo exhibition at Susan Caldwell Gallery, New York, which is Golub's first solo gallery show in New York in twenty years; solo show of recent work at the Institute of Contemporary Arts, London; awarded Honorary Doctor of Fine Arts, School of the Art Institute of Chicago.
1983-84	Appointed John C. Van Dyck Professor of Visual Art, Mason Gross School of the Arts, Rutgers University, New Jersey. Active in "Artists Call Against U.S. Intervention in Central America."

Solo Exhibitions	**1950**	Contemporary Gallery, Chicago, Ill.
	1951	Purdue University, West Lafayette, Ind.
	1952	George Wittenborn & Co., New York, N.Y. (also 1954)
	1954	Artists Gallery, New York, N.Y.
	1955	Feigl Gallery, New York, N.Y. (also 1956) Allan Frumkin Gallery, Chicago, Ill. (also 1956–64)
	1956	Pasadena Museum of Art, Pasadena, Calif. Pomona College, Claremont, Calif.
	1957	Institute of Contemporary Arts, London, England
	1959	Allan Frumkin Gallery, New York, N.Y. (also 1960–63)
	1962	Galerie Iris Clert, Paris, France Hanover Gallery, London, England
	1963	Gallery A, Melbourne, Australia
	1964	Galerie Iris Clert and Galerie Europe (joint exhibition), Paris, France *Leon Golub: Retrospective*, Stella Elkins Tyler School of Fine Art, Temple University, Philadelphia, Pa.
	1966	*Leon Golub: Retrospective*, University of Chicago, Chicago, Ill.
	1968	Pro Grafica Arte, Chicago, Ill.
	1970	*Leon Golub: Paintings*, Hayden Gallery, Massachusetts Institute of Technology, Cambridge, Mass. LoGiudice Gallery, Chicago, Ill.
	1970-71	Galerie Darathea Speyer, Paris, France (also 1984) National Gallery of Victoria, Melbourne, Australia
	1972	Bienville Gallery, New Orleans, La. (also 1977) Herbert Lehman College, Bronx, N.Y. Sloane/O'Sickey Gallery, Cleveland, Ohio
	1973	*Golub*, Musée de L'Abbaye Saint Croix, Les Sables d'Olonne

1974	*Leon Golub: A Retrospective of Paintings from 1947 to 1973*, Museum of Contemporary Art, Chicago, Ill. (traveled to New York Cultural Center in 1975)
1975	New Jersey State Museum, Trenton, N.J.
1976	Haverford College, Haverford, Pa.
	Leon Golub: Paintings 1966 – 76, San Francisco Art Institute, San Francisco, Calif.
1977	Olympia Galleries, Philadelphia, Pa.
	Walter Kelly Gallery, Chicago, Ill.
1978	Colgate University, Hamilton, N.Y.
	State University of New York, Stony Brook, N.Y.
1979	Visual Arts Museum, School of Visual Arts, New York, N.Y.
1980	Protetch-McIntosh Gallery, Washington, D.C.
1982	*Leon Golub, Mercenaries and Interrogations*, Institute of Contemporary Arts, London, England
	Kipnis Works of Art, Atlanta, Ga.
	Susan Caldwell Inc., New York, N.Y. (also 1984)
	Young-Hoffman Gallery, Chicago, Ill.
1983	Honolulu Academy of Arts, Honolulu, Hawaii
	Leon Golub: Mercenaries, Interrogations, and Other Works, Sarah Campbell Blaffer Gallery, University of Houston, Houston, Tex. (traveled)
	Matrix/Berkeley 58: Leon Golub, University Art Museum, University of California, Berkeley, Calif.
1984	Gallery Paule Anglim, San Francisco, Calif.

Two-Person Exhibitions	**1958**	*Leon Golub/Nancy Spero*, Indiana University, Bloomington, Ind.
	1960	*Leon Golub/Balcomb Greene*, Centre Culturel Americain, Paris, France
	1974	*Leon Golub/Philip Pearlstein*, Horace Mann School, New York, N.Y.
	1981	*Leon Golub/Nancy Spero*, Swarthmore College, Swarthmore, Pa.
	1982	*Leon Golub/Nancy Spero*, Tweed Arts Group, Plainfield, N.J.
	1983	*Leon Golub/Nancy Spero*, Sarkis Galleries, Center for Creative Studies, College of Art and Design, Detroit, Mich.
		Leon Golub/Nancy Spero, University of New Mexico, Albuquerque, N.Mex.
Group Exhibitions	**1947**	*1st Veterans Annual*, School of the Art Institute of Chicago, Chicago, Ill.
	1948	*Exhibition Momentum*, Roosevelt College, Chicago, Ill. (also 1949–58 at various locations)
	1953	*International Exhibition of Modern Graphics*, Salzburg, Vienna, Linz, Austria; Berlin, Munich, Hamburg, West Germany
	1954	*Carnegie International*, Carnegie Institute, Pittsburgh, Pa. (also 1964, 1967)
		Expressionism, 1900–1950, Walker Art Center, Minneapolis, Minn.
		61st American Exhibition, Art Institute of Chicago, Chicago, Ill.
		Younger American Painters, Solomon R. Guggenheim Museum, New York, N.Y.
	1955	Institute of Contemporary Arts, Houston, Tex.
		Whitney Museum of American Art, New York, N.Y. (also 1956)
	1957	*University of Illinois American Exhibition*, Urbana, Ill. (also 1961, 1963, 1965)
		University of Nebraska American Exhibition, Lincoln, Nebr. (also 1960, 1961, 1963)
	1958	*Surrealist and Dada Sculpture*, Arts Club, Chicago, Ill.
	1959	*Museum Directors' Choice*, Baltimore Museum, Baltimore, Md.
		New Images of Man, Museum of Modern Art, New York, N.Y.
		63rd American Exhibition, Art Institute of Chicago, Chicago, Ill.
	1961	*Larry Aldrich Collection*, American Federation of the Arts, New York, N.Y. (traveled)

Private Worlds, American Federation of the Arts, New York, N.Y. (traveled)

2nd International Biennial, Academy of Fine Arts, Mexico City, Mexico

1962 *Corcoran Museum Annual*, Corcoran Gallery of Art, Washington, D.C.

The Figure, Museum of Modern Art, New York, N.Y.

Huit Artistes de Chicago, Galeries du Dragon, Paris, France

La Jeune Peinture Mediterranean, Nice, France

La Piccola Biennale, Galerie Iris Clert, Venice, Italy

São Paolo Biennale, São Paolo, Brazil

6 Decades of the Figure in American Painting, University of Iowa, Iowa City, Iowa

65th American Exhibition, Art Institute of Chicago, Chicago, Ill.

1963 *Art: USA Now*, Milwaukee Art Institute, Milwaukee, Wisc. (traveled)

Bertrand Russell Peace Foundation Exhibition, Woburn Abbey, England

Dunn International, Tate Gallery, London, England; Beaverbrook Art Gallery, New Brunswick, Canada

Forum, Abbey Saint-Pierre, Ghent, Belgium

New Directions, San Francisco Museum of Modern Art, San Francisco, Calif.

Realities Nouvelles, Musée d'Art Moderne, Paris, France

1964 American Academy of Arts and Letters, New York, N.Y. (also 1970, 1973)

Documenta III, Kassel, West Germany

The Figure Since Picasso, Ghent, Belgium

Fine Arts Pavilion, New York World's Fair, Flushing, N.Y.

Graphics 1963, University of Kentucky, Lexington, Ky.; Smithsonian Institution, Washington, D.C. (traveled)

Mythologiques Quotidiennes, Musée d'Art Moderne, Paris, France

160th Annual, Pennsylvania Academy, Philadelphia, Pa.

1965 *American Painting*, Virginia Museum of Fine Arts, Richmond, Va.

The Figure International, American Federation of the Arts, New York, N.Y. (traveled)

Los Angeles Peace Tower, Los Angeles, Calif.

161st Annual, Pennsylvania Academy, Philadelphia, Pa.

Il Presente Contestato, Museo Civico, Bologna, Italy

7 Decades of Modern Art, Public Education Association, Cordier-Ekstrom Gallery, New York, N.Y. (also 1966)

USA: Art Vivant, Musée des Augustins, Toulouse, France.

1967 *Collage of Indignation*, "Angry Arts," New York University, New York, N.Y.
 Drawings by 13 Americans, University of Washington, Seattle, Wash.
 Le Monde en Question, Musée d'Art Moderne, Paris, France
 Sources for Tomorrow, Smithsonian Institution, Washington, D.C. (traveled 1967 – 69)
 II International der Zeichnung, Darmstadt, West Germany

1968 *Art and Liberation*, Nihon Gallery, Tokyo, Japan
 La Figuration depuis le Guerre, Saint-Etienne, France
 Mayor Richard Daley, Feigen Gallery, Chicago, Ill. (traveled)
 The Native's Return, Ravinia Music Festival, Ravinia, Ill.
 The Obsessive Image, 1960 – 68, Institute of Contemporary Arts, London, England
 10 Downtown, Colgate University, Hamilton, N.Y.

1969 *Il Bienial International del Deporte en las Bellas Artes*, Madrid, Spain
 Critic's Choice, New York State Council on the Arts, New York, N.Y. (traveled 1969 – 70)
 L'oeil Ecoute, Avignon Arts Festival, Avignon, France
 Salon Comparaisons, Paris, France

1970 *Flag Show*, Judson Memorial Church, New York, N.Y.
 Peace Exhibition, Philadelphia Museum of Art, Philadelphia, Pa.

1971 *Blossom-Kent Festival*, Kent State University, Kent and Blossom, Ohio

1972 *Bertrand Russell Centenary Year Exhibition*, Woburn Abbey, England
 Chicago Imagist Art, Museum of Contemporary Art, Chicago, Ill.; New York Cultural Center,
 New York, N.Y.
 Collage of Indignation II, New York Cultural Center, New York, N.Y.
 International Art Manifesto for the Legal Defense of Political Prisoners, Berkeley and San Francisco, Calif.

1973 Bergman Gallery, University of Chicago, Chicago, Ill.
 Fine Arts Center, New York Institute of Technology, New York, N.Y.
 Graphics Exhibition, Center for Continuing Education, University of Chicago, Chicago, Ill.
 School of Art and Architecture, Yale University, New Haven, Conn.

1974 *Continuing Graphic Protest . . . and the Grand Tradition*, Pratt Graphic Center Gallery, New York,
 N.Y. (traveled)
 Viva Chile, Paris, France

1975 *Artists for Amnesty*, Onnasch Gallery, New York, N.Y.

1976 *A Decade of American Political Posters: 1965 – 75*, Westbeth Galleries, New York, N.Y.
Exhibition of Liturgical Arts, 41st International Eucharistic Congress, Philadelphia, Pa.
Koffler Foundation Collection, Springfield Art Association, Springfield, Ill. (traveled 1976–80)
The Michener Collection: American Painting of the 20th Century, University of Texas, Austin, Tex.
(traveled)
150th Annual, National Academy of Design, New York, N.Y.
Project Rebuild, Grey Gallery, New York University, New York, N.Y. (traveled)
Visions: Distinguished Alumni Exhibition, 1945 to Present, School of the Art Institute of Chicago,
Chicago, Ill.

1977 *Invitational*, 55 Mercer Street, New York, N.Y.
Memorial to Orlando Letelier, Cayman Gallery, New York, N.Y.
Paris-New York, Centre d'Art et de Culture Georges Pompidou, Paris, France
Recent Portraits, Renaissance Society, University of Chicago, Chicago, Ill.

1978 *Chicago: The City and Its Artists*, University of Michigan, Ann Arbor, Mich.
Conference on Human Rights, Eagleton Institute, Rutgers University, New Brunswick, N.J.
N.A.M.E. Gallery, Chicago, Ill.

1979 *Centennial Exhibition*, Art Institute of Chicago, Chicago, Ill.
Harlem Renaissance Exhibit III, City College of New York, N.Y.
Political Comment in Contemporary Art, State University College, Potsdam, N.Y.; State University of
New York, Binghamton, N.Y.

1980 *American Figurative Painting 1950 – 1980*, Chrysler Museum, Norfolk, Va.
Art and the Law, Minneapolis Institute of Arts, Minneapolis, Minn.
Art of Conscience, the Last Decade, Wright State University, Dayton, Ohio (traveled 1981 – 82)
George Irwin Collection, Krannert Art Museum, University of Illinois, Champaign, Ill.
Mavericks (Aspects of the Seventies), Rose Art Museum, Brandeis University, Waltham, Mass.
30th Anniversary Exhibit, Contemporary Art Workshops, Chicago, Ill.

1981 *Crimes of Compassion*, Chrysler Museum, Norfolk, Va.
Figure in American Art, Art Museum of Southwest Texas, Corpus Christi, Tex.; University of
North Dakota, Grand Forks, N.Dak.

Figures: Forms and Expressions, Hallwalls, Buffalo, N.Y.

Heads, Institute for Art and Urban Resources at P.S. 1, Long Island City, N.Y.

Realism, Bard College, New York, N.Y.

Running, International Running Center, New York, N.Y.

20th Century Prints, Illinois Arts Council Gallery, Chicago, Ill.

1982 *American Figurative Expressionism 1950–1960*, Marilyn Pearl Gallery, New York, N.Y.

Angry Art, Catherine Street Artists Project, New York, N.Y.

Atomic Salon, Ronald Feldman Gallery, New York, N.Y.

Beyond Aesthetics, Henry Street Settlement, New York, N.Y.

Dangerous Works, Parsons School of Design, New York, N.Y.

Four Artists, Art Galaxy, New York, N.Y.

Homo Sapiens, Aldrich Museum of Contemporary Art, Ridgefield, Conn.

Luchar!, Taller Latinoamericano, New York, N.Y.

Mixing Art and Politics, Randolph Street Gallery, Chicago, Ill.

The Monument Redefined, Gowanus Memorial Artyard, Brooklyn, N.Y.

New Portraits: Behind Faces, Dayton Art Institute, Dayton, Ohio

Painting and Sculpture Today, Indianapolis Museum of Art, Indianapolis, Ind.

Photographies d'Artistes, Galerie France, Morin, Montreal, Canada

Realism and Realities: The Other Side of American Painting 1940–1960, Rutgers University, New Brunswick, N.J. (traveled)

Selections from the Dennis Adrian Collection, Museum of Contemporary Art, Chicago, Ill.

1983 American Academy and Institute of Arts and Letters, Hassam and Speicher Fund Purchase Exhibition, New York, N.Y.

Art Couples III: Leon Golub and Nancy Spero, Institute for Art and Urban Resources at P.S. 1, Long Island City, N.Y.

Artists for Nuclear Disarmament, University of Vermont, Burlington, Vt. (traveled)

Bodies and Souls, Artists Choice Museum Exhibition, Marisa Del Re Gallery, New York, N.Y.

Chicago Artists: Continuity and Change, 714 S. Dearborn, Chicago, Ill.

Drawings and Heads of State, Signet Arts, St. Louis, Mo.

Faces Since the Fifties—A Generation of American Portraiture, Center Gallery, Bucknell University, Lewisburg, Pa.

New Work New York, Newcastle Polytechnic Gallery, Newcastle, England

New York Painting Today, Carnegie Mellon Institute, Pittsburgh, Pa.

1983 Biennial, Whitney Museum of American Art, New York, N.Y.

Peace on Earth: Pastorals and Politics, Tweed Arts Group, Plainfield, N.J.

Portraits for the 80's, Protetch McNeil Gallery, New York, N.Y.

Portraits on a Human Scale, Whitney Museum of American Art, Downtown Branch at Federal Hall National Memorial, New York, N.Y.

Resistance Festival for Nicaraguan Artists, Danceteria, New York, N.Y.

Sex and Violence, Contemporary Arts Center, New Orleans, La.

Terminal New York, Harborside Industrial Center, Brooklyn, N.Y.

A Time for Anger, Institute for Art and Urban Resources at P.S. 1, Long Island City, N.Y.

Walls of the 70's, Queensborough Community College, Bayside, N.Y. (traveled)

The War Show, State University of New York, Stony Brook, N.Y.

What Artists Have To Say About Nuclear War, Nexus Gallery, Atlanta, Ga.

1983-84 *Big Paintings*, Protetch McNeil Gallery, New York, N.Y.

Brave New Works: Recent American Painting and Drawing, Museum of Fine Arts, Boston, Mass.

1984 *Art and Politics*, Queensborough Community College, Bayside, N.Y.

Art as Social Conscience, Edith C. Blum Art Institute, Bard College Center, New York, N.Y.

Artists Call Against U.S. Intervention in Central America, Benefit Exhibition, Judson Memorial Church and Leo Castelli Gallery, New York, N.Y.

Beauties and Beasts, Pratt Manhattan Center Gallery, New York, N.Y.

Body Politic, Tower Gallery, New York, N.Y.

Cash Gallery, New York, N.Y.

Chicago Cross Section, Ohio University, Athens, Ohio

The Human Condition – San Francisco Museum of Modern Art Biennale III, San Francisco, Calif.

The New Portrait, Institute for Art and Urban Resources at P.S. 1, Long Island City, N.Y.

1 + 1 = 2, Bernice Steinbaum Gallery, New York, N.Y. (traveling through 1986)

ROSC/The Poetry of Vision, Dublin, Ireland

10th Anniversary Exhibition, Hirshhorn Museum, Washington, D.C.

Articles, Catalogs, and Reviews

Adrian, Dennis. "Leon Golub Returns Home in all his Crushing Power," *Chicago Daily News*, September 8, 1974.

————. *Leon Golub* (exhibition catalog) Trenton: New Jersey State Museum, 1975.

Alloway, Lawrence. *Leon Golub, Paintings from 1956–57*. Chicago: Allan Frumkin Gallery, 1957.

————. *Leon Golub* (exhibition catalog) London: Hanover Gallery, 1962.

————. "Leon Golub: Arts & Politics," *Artforum* 13, no. 2 (October 1974): 66–71.

————. "Leon Golub, the Development of His Art," *Leon Golub: A Retrospective Exhibition of Paintings from 1947 to 1973* (exhibition catalog) Chicago: Museum of Contemporary Art, 1974.

————. "Art," *The Nation*, February 19, 1977, pp. 221–22.

Arac, Jonathan, ed. "Engagements: Postmodernism, Marxism, Politics," *Boundary* 2 11, no. 1–2 (Fall/Winter 1982–83).

Artner, Alan. "Linking Man to Myth in a Golub Retrospective," *Chicago Tribune*, September 9, 1974.

————. "Leon Golub Portraits Stage a Play of Power," *Chicago Tribune*, February 27, 1977.

Baigell, Matthew. "'The Mercenaries': An Interview with Leon Golub," *Arts Magazine* 55, no. 9 (May 1981): 167–69.

Bain, Lisa. "Openings/Leon Golub," *Esquire* (March 1984): 235.

Bird, Jon. "Leon Golub: 'Fragments of Public Vision,' *Leon Golub, Mercenaries and Interrogations* (exhibition catalog) London: Institute of Contemporary Arts, 1982.

Brenson, Michael. "Art: From Leon Golub, Political Thugs Gallery," *New York Times*, February 10, 1984, p. C20.

————. "Can Political Passion Inspire Great Art?," *New York Times*, Arts & Leisure, April 28, 1984.

Brett, Guy. "Raunchy, Irritable, Mocking," *City Limits* July 16–22, 1982, pp. 47–48.

Brown, Daniel. "Leon Golub," *Dialogue* (May/June 1984): 19.

Bryant, Edward. *Portraits of Power* (exhibition catalog) Hamilton, New York: Colgate University, 1978.

————. "Leon Golub/Nancy Spero," *ArtSpace* (Spring 1983): 80–81.

Bull, Bart. "Golub's Didactic Warriors," *Express* [Berkeley, California], March 11, 1983, p. 6.

Canaday, John. "Leon Golub," *New York Times*, November 24, 1963.

Carroll, Paul. "Here Come the Chicago Monsters," *Chicago Perspective* (April 1964).

Daniels, Kate and Richard Jones. "Art and Guns," *Poetry East* [Charlottesville, Va.], nos. 9–10 (Winter 1982/Spring 1983): 159, 284–86.

Donohoe, Victoria. "Golub's Figures Appear to Live in this World," *Philadelphia Inquirer*, February 8, 1976.

————. "Two Rare Artists Who Put Their Politics . . .," *Philadelphia Inquirer*, Weekend Section, November 13, 1981.

Dormer, Peter. "Art Lobby," *Art Monthly* [London, England] (September 1982).

Dreiss, Joseph. "Leon Golub's Gigantomachies: Pergamon Revisited," *Arts Magazine* 55, no. 9 (May 1981): 174–76.

————. "Leon Golub," *Arts Magazine* 56, no. 5 (January 1982): 10.

Elsen, Albert. *Leon Golub* (exhibition catalog) New York: Allan Frumkin Gallery, 1959.

Feaver, William. "Leon Golub," *Sunday Observer* [London, England], August 1, 1982.

Ferruli, Helen. "Leon Golub Talks of Painting," *Art Insight* (Part 1) Indianapolis: Indianapolis Institute of Art, May 1983.

————. "Leon Golub Discusses His Art," *Art Insight* (Part 2) Indianapolis: Indianapolis Institute of Art, June 1983.

Fournet, Claude. *Golub* (exhibition catalog) Musée de L'Abbaye Saint Croix, Les Sables d'Olonne.

French, Christopher. "Leon Golub: The Voice of Outrage," *Artweek* 14, no. 11, March 19, 1983, p. 1.

————. "The Propaganda of Pessimism," *Artweek* 15, no. 13, March 31, 1984, p. 62.

Fuller, Peter. "Chicago for Real: Leon Golub," *New Society* [London, England], July 26, 1979, pp. 198–99.

Gassiot-Talabot, G. "Les Gigantomachies de Golub," (exhibition newsletter) *iris. time*, no. 15, Paris: Galerie Iris Clert, May 27, 1964.

————. "Golub: les mythes a l'heure du napalm," *Opus International*, no. 23 (March 1971): 36–37.

Gerard, Michel. "Les reportages de Golub," *Opus International*, no. 93 (Spring 1984): 49–50.

Gordon, Mary. "Art and Politics," *Strata* 1, no. 2, New York: School of Visual Arts, 1975.

Guthrie, Derek. "Art Politics and Ethics: Interview with Leon Golub and Nancy Spero," *New Art Examiner* 4, no. 7 (April 1977): 6–7.

Handy, Ellen. "Leon Golub," *Arts Magazine* 58, no. 8 (April 1984): 40.

Hayes, John. "Massive Canvases Record 'Brute Facts and Brutal Events,' " *Matchbox*, New York: Amnesty International USA, February 1983, p. 11.

Horsfield, Kate. "Profile: Leon Golub," *Profile* 2, no. 2, Chicago: Video Data Bank, School/Art Institute of Chicago, March 1982.

Januszczak, Waldemar. "Prisoners of a Tortured Conscience," *Manchester Guardian*, July 20, 1982, p. 10.

Kerrigan, Anthony. "Cronica de NorteAmerica," *Goya*, no. 7 [Lazaro Galdiano Museum, Madrid] (July – August 1955).

Kind, Joshua. "Sphinx of the Plains: A Chicago Visual Idiom," *Chicago Review* 17, nos. 2 – 3 (1964).

Klein, Barbara. *Leon Golub: Paintings* (exhibition catalog) Cambridge, Mass.: Hayden Gallery, Massachusetts Institute of Technology, 1970.

Klekner, Ken and David Miller. "Spero-Golub, Art at the Speed of Life," *Grey City Journal* [Chicago], October 28, 1983.

Kozloff, Max. "The Late Roman Empire in the Light of Napalm," *Art News* 69, no. 7 (November 1970): 58 – 60, 76 – 78.

Kuspit, Donald. "Golub's Assassins: An Anatomy of Violence," *Art in America* 63, no. 3 (May – June 1975): 62 – 65.

————. "Leon Golub: Power to the Portrait," *Art in America* 67, no. 4 (July – August 1979): 89 – 90.

————. "Leon Golub's Mural of Mercenaries: Aggression 'Ressentiment,' and the Artist's Will To Power," *Artforum* 14, no. 9 (May 1981): 52 – 57.

————. "Art Couples," (exhibition statement), Institute for Art and Urban Resources at P.S. 1, Long Island City, N.Y., 1983.

Kuspit, Donald and Rudolf Baranik. "Art and Politics: An Exchange," *Art in America* 63, no. 5 (September – October 1975): 36 – 37.

Leja, Michael. "Aspects of the 70's: Mavericks" (exhibition catalog) Waltham, Mass.: Rose Art Museum, Brandeis University, 1980, pp. 4 – 6.

Levin, Kim. "Voice Centerfold: Art," *Village Voice*, January 21 – 26, 1982, p. 56.

————. "Power to the Painter," *Village Voice*, February 28, 1984, p. 79.

Linhares, Philip. *Leon Golub: Paintings* 1966 – 76 (exhibition catalog) San Francisco: San Francisco Art Institute, 1976.

Lippard, Lucy R. "Making Manifest," *Village Voice*, January 27, 1982, p. 72.

Luhan, J. Michael. "Latin American Holocaust," *Penthouse* (September 1981): 52–53.

Malone, Patrick and Peter Selz. "Is there a New Chicago School?," *Art News* 54, no. 2 (October 1955): 36–39.

McBride, Henry. "Americans Looking East, Looking West," *Art News* 53, no. 9 (May 1954): 32, 54.

Melville, Robert. *Leon Golub* (exhibition catalog) London: Institute of Contemporary Arts, 1957.

Newman, Michael. "Interview with Leon Golub," *Leon Golub, Mercenaries and Interrogations* (exhibition catalog) London: Institute of Contemporary Arts, 1982.

Padgham, Gay. "Killers Go Up Against the Wall," *Morning Star* [London, England], August 10, 1982.

Perreault, John. "Assassins," *Soho Weekly News*, April 10, 1975, p. 15.

——— . "Realpolitick," *Soho Weekly News*, January 26, 1982, p. 24.

Phillips, Tony. "Leon Golub: Portraits of Political Power," *New Art Examiner* 5, no. 4 (January 1978): 1.

Pincus-Witten, Robert. "Leon Golub," *Art International* 6, no. 1 (February 1962): 51–52.

——— . "Golub on Three Levels," (exhibition newsletter) *iris.time*, no. 15, Paris: Galerie Iris Clert, May 27, 1964.

——— . "A Note on Golub," *Artforum* 6, no. 10 (Summer 1968): 46–47.

——— . "Entries: Post-Epistemic Dilemma," *Arts Magazine* 56, no. 1 (September 1983): 110–12.

Ratcliff, Carter. "Contemporary American Art," *Flash Art* 108–16 (Summer 1982): 32–35.

——— . "Expressionism Today: An Artists Symposium," *Art in America* 70, no. 11 (December 1982): 64.

——— . "Theater of Power," *Art in America* 72, no. 1 (January 1984): 74–82.

Roberts, John. "Leon Golub's Mercenaries and Interrogations," *Art Monthly* [London, England] (September 1982).

Robins, Corinne. *Leon Golub* (exhibition catalog) Melbourne, Australia: National Gallery of Victoria, 1970–71.

——— . "Leon Golub: The Faces of Power," *Arts Magazine* 51, no. 6 (February 1977): 110–11.

——— . "Leon Golub: In the Realm of Power," *Arts Magazine* 55, no. 9 (May 1981): 170–73.

Robson, R.R. and J.C. Roth. "Revealing the Edges of Society," *Allegheny* 3, no. 2 (Spring 1983).

Rose, Barbara and Irving Sandler. "Sensibility of the Sixties," *Art in America* 55, no. 1 (January–February 1967): 55.

Rosenberg, Harold. "Aesthetics of Mutilation," *New Yorker*, May 12, 1975.

Samaras, Connie. "Nancy Spero and Leon Golub: An Interview," *Detroit Focus Quarterly* 2, no. 4 (December 1983).

Sandler, Irving. "An Interview with Leon Golub," *Arts Magazine* 44, no. 4 (February 1970).

——————. "Interview: Leon Golub Talks with Irving Sandler," *Journal, Archives of American Art* 18, no. 1 (1978): 11–18.

Schjeldahl, Peter. "Red Planet," *Village Voice*, October 26, 1982, pp. 96, 111.

Schulze, Franz. "Chicago Letter," *Art International* 11, no. 1, January 20, 1967.

——————. "One Man's Quest for a Symbol of our Time–Leon Golub's Fearsome Giants," *Chicago Daily News*, February 22, 1969.

——————. "Majestic Existentialism," *Art News* 73, no. 2 (October 1974): 87–88.

——————. "Art," *Chicago Daily News*, March 4, 1977.

Schoenfeld, Ann. "Leon Golub," *Arts Magazine* 57, no. 4 (December 1982): 41.

Schwartz, Therese. "The Politicalization of the Avant-Garde," *Art in America* 59, no. 6 (November–December 1971): 96–105.

Selz, Peter. "A New Imagery in American Painting," *College Art Journal* 15, no. 4 (Summer 1956): 290–301.

——————. *Leon Golub, Balcomb Greene* (exhibition catalog) Paris: Centre Culturel Americain, 1960.

——————. *A Blunt View of Power and Violence on a Grand Scale* (exhibition catalog and University Bulletin) Berkeley: University Art Museum, University of California, March 1983.

Siegel, Jeanne. "Leon Golub/Hans Haacke: What Makes Art Political?," *Arts Magazine* 58, no. 8 (April 1984): 107–10.

Smith, Edith and Alan Fern. "Expressionism and Emotion in American Painting," *Chicago Review* 8, no. 3 (1954).

Speyer, A. James. *Leon Golub, Retrospective Exhibition* (exhibition catalog) Philadelphia: Stella Elkins Tyler School of Fine Art, Temple University, 1964.

Spurling, John. "Larger than Life-Size," *New Statesman* 104, no. 2682, August 13, 1982.

Stevens, Mark. "Art on the Barricades," *Newsweek*, February 6, 1984, pp. 70–71.

Stubbs, Ann. "Interview," *Fire in the Lake* 1, no. 4 (July–August 1976).

Talone, Zoe. "Leon Golub's 'Mercenaries and Interrogations,' " *New Times* [Syracuse, New York], no. 689, May 30, 1984, cover and pp. 7–8.

Taylor, John Russell. "An Ominous View of the March of Progress," *Times* [London, England], August 3, 1982.

Tully, Judd. "Flash Art Reviews," *Flash Art*, no. 106 (February–March 1982): 56.

————. "Leon Golub's Leftist Tatoo," *Art/World* 8, no. 5 (February 1984): 1, 4.

Ullmann, Sabrina. "Leon Golub–The Aesthetics of Power," *Fresh Weekly* [Portland, Oregon], November 15, 1983, cover and pp. 10–11.

Witz, Robert and Joe Jewis. *Appearances* (Spring 1983): 12, 31–32, 73, 93–96.

By the artist

"A Law Unto Himself," *Exhibition Momentum–A Forum, 9 Viewpoints*, Chicago, Illinois, 1950.

"A Critique of Abstract Expressionism," *College Art Journal* 14, no. 2 (Winter 1955): 142–47.

"Considerations on Contemporary Art," *Art League News* 3, no. 4 [Winnetka, Illinois] (December 1955).

"Exhibition catalog statement," Allan Frumkin Gallery, New York, New York, 1963.

"The Artist as an Angry Artist," *Arts Magazine* 41, no. 6 (April 1967): 48–49.

"Bombs and Helicopters, the Art of Nancy Spero," *Caterpillar* 1 (January 1967).

Review of *Styles of Radical Will* by Susan Sontag, *Caterpillar* 8/9 (October 1969): 127–28.

"Letter," *Artforum* 7, no. 7 (March 1969).

"Regarding the Lehman and Rockefeller Gifts to the Metropolitan Museum," *Artforum* 9, no. 3 (November 1970): 40–41.

"Utopia/Anti-Utopia," *Artforum* 10, no. 9 (May 1972): 33–34.

"2D/3D," *Artforum* 11, no. 7 (March 1973): 60–68.

"16 Whitney Museum Annuals of American Painting, Percentages 1950–1972," *Artforum* 11, no. 7 (March 1973).

"What Works?," *Art Criticism* 1, no. 2 (Fall 1979): 29–48.

"Too Much of What?," *Art Workers News* 10 (June 1981): 21.

"On Being T (Taken for Granted)," *New Art Examiner* (October 1981): 3.

"Interrogations, Mercenaries, White Squads," edited talk with Leon Golub, FERRO-BOTANICA, no. 3 (November 1982): 11–23.

The Flue 3, no. 1 (Winter 1983), Franklin Furnace Archive.

Selected Books

Andersen, Wayne. *American Sculpture in Process: 1930–1970*. New York: New York Graphic Society, 1975, pp. 136–40, 143–44.

Fuller, Peter. "Leon Golub," *Beyond the Crisis in Art*. London: Writers and Readers Publishing Cooperative Ltd., 1980, pp. 104–09.

Kuspit, Donald. *The Critic as Artist: The Intentionality of Art*. Ann Arbor, Michigan: UMI Press, 1984.

Miller, James A. and Paul Herring. *The Arts and the Public*. Chicago: University of Chicago Press, 1967, pp. 195–211, 223–24.

Pradel, Jean-Louis. *World Art Trends*. New York: Harry Abrams, 1983.

Sandler, Irving. *The New York School: The Painters and Sculptors of the Fifties*. New York: Harper and Row, 1978, pp. 133, 135–36.

Schulze, Franz. *Fantastic Images: Chicago Art Since 1945*. Chicago: Follett Publishing Company, 1972, pp. 40–49.

Schwartz, Barry. *The New Humanism*. New York: Praeger Publishers, 1974.

Selz, Peter. *New Images of Man*. New York: The Museum of Modern Art, 1959.

Weller, Allan. *Art: USA Now*. Lucerne: C.J. Bucher, 1962.

Other

Attica Book, Art Work by Black and White Artists; Writings of Prison Inmates. New York: Black Emergency Cultural Coalition and the Artists and Writers Protest, 1972.

Conspiracy – The Artist as Witness (Print portfolio – 12 artists). New York: Center for Constitutional Rights, 1972.

Peace Portfolio (16 artists, 18 poets). New York: Artists and Writers Protest, 1967.

The Mercenary Game, Documentary film, Alain d'Aix, Jean-Claude Burger, Morgan Laliberte. Production: InformAction and The Societe, The Radio Television du Quebec, Canada, 1983.

Staff

Kimball Augustus, *Security*

Eric Bemisderfer, *Preparator*

Gayle Brandel, *Acting Administrator*

Mary Clancy, *Administrative Assistant*

Pamela Freund, *Public Relations/Special Events Assistant*

Carmen Fuentes, *Receptionist*

Lynn Gumpert, *Curator*

John K. Jacobs, *Registrar*

Ed Jones, *Education Director*

Elon Joseph, *Security*

Marcia Landsman, *Curatorial Coordinator*

Eileen Pryor McGann, *Manager of Catalog Subscription Program*

Maureen Mullen, *Admissions/Bookstore*

Susan Napack, *Admissions/Bookstore Manager*

John Neely, *Youth Program Instructor*

Lisa Parr, *Curatorial Assistant*

Ned Rifkin, *Curator*

Jessica Schwartz, *Director of Public Relations/Special Events*

Charles A. Schwefel, *Director of Planning and Development*

Maureen Stewart, *Bookkeeper*

Marcia Tucker, *Director*

Lorry Wall, *Admissions/Bookstore*

Brian Wallis, *Editorial Consultant*

Judith Wilson, *Project Director*, "Art Criticism for Young Adults"

Tim Yohn, *Editor*

Photo Credits Alinari/Art Resource (figs. 3, 4); Diana Church (fig. 7, Cats. 25, 26, 29, 32, 33, 34); John D. Schiff (Cat. 3); Leonard De Caro (fig. 5, Cats. 14, 18, 19); Augustin Dumage (Cats. 10, 11, 12); Léni Iselin (Cat. 13); Bevan Davies (Cat. 22); Zindman/Fremont (Cat. 35); David Reynolds (Cats. 38, 39, 40, 41)

This publication was organized by Marcia Landsman, Publications Coordinator; designed by Katy Homans with Eric Ceputis, Homans/Salsgiver; typeset by Trufont Typographers; and printed by Eastern Press, Inc.